Anatomy
for Fantasy Artists

Anatomy
for Fantasy Artists

An illustrator's guide to creating action
figures and fantastical forms

Glenn Fabry

Additional text by **Ben Cormack**

D&C
David and Charles

A DAVID & CHARLES BOOK

First published in 2005 in the UK by
David & Charles Publishers
Brunel House, Newton Abbot
Devon TQ12 4PU

ISBN 0 7153 2028 9

Conceived, designed, and produced by
Quarto Publishing plc
The Old Brewery
6 Blundell Street
London N7 9BH

QUAR.ASC

Quarto would like to thank Al Davison for the original
idea that was the starting point for this book.

Project Editor Susie May
Art Editor Claire Van Rhyn
Assistant Art Director Penny Cobb
Designer Ross George
Editor Hazel Harrison
Assistant Editor Mary Groom

Picture Researcher Claudia Tate
Photographer Paul Forrester and Martin Norris
Proofreader Alison Howard
Indexer Geraldine Beare

Art Director Moira Clinch
Publisher Piers Spence

Manufactured by Provision Pte Ltd, Singapore
Printed by Star Standard (PTE) Ltd, printed in Singapore

9 8 7 6 5 4 3 2 1

Contents

Preface
fantasy artists today

When I was a kid I loved fantasy and science fiction, from superhero comics to Hammer horror, and Star Wars Episode IV to Monty Python's Flying Circus. I wanted nothing more than to enter these other worlds, and although I felt a million miles away from them in my little bedroom near London, I had one thing that I could do; I could draw.

I went to art school in the late 1970s, where all of the comic book stuff I wanted to do was dismissed as badly-drawn escapism. But I took all I learned about the techniques of classical art and used it to produce better-drawn escapism. And for the last 20 years I've been a freelance illustrator working mainly in the fantasy genre.

This book is intended to show you how to apply the patina of reality to the depiction of fantasy archetypes, specifically in terms of understanding anatomy and dynamics, and so create informed daydreams. Reference is important, but you can't be confined by this when creating the picture you want – you need to be able to use your imagination so you can twist and turn your characters to your own ends. This is where the fantasy begins.

Drawing styles

The power and effectiveness of your illustrations will be partly dictated by your ability – any picture has the potential to be the best picture you're able to draw – and partly by the environmental factors, such as the books and magazines you read, that have influenced you to pick up a pencil in the first place.

There are a few laws in fantasy art – it needs to be bold, exaggerated and larger-than-life, or it just wouldn't be fantasy art – but apart from that, originality and innovation play a big part in producing work that is attention-grabbing and fresh.

▼ **Voluptuous and womanly**
Liam Sharp
The heavily muscled, grim-featured creature in the background looks menacing yet cautious as he looks upon his female opponent – whose bunched back muscles and grotesque clawed arm reveal she is no helpless girl. She is ready to do battle, and the beast looking upon her knows it.

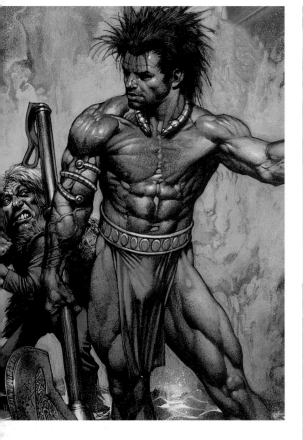

▲ **Celtic hero**
Glenn Fabry
This hero's rippling musculature and confident poise, especially in contrast to his sidekick's cowering, confirm his prowess as a warrior. His Celtic adornments and the strange way in which the light plays on the water in which he's standing suggest that he also operates in a dimension beyond the purely physical.

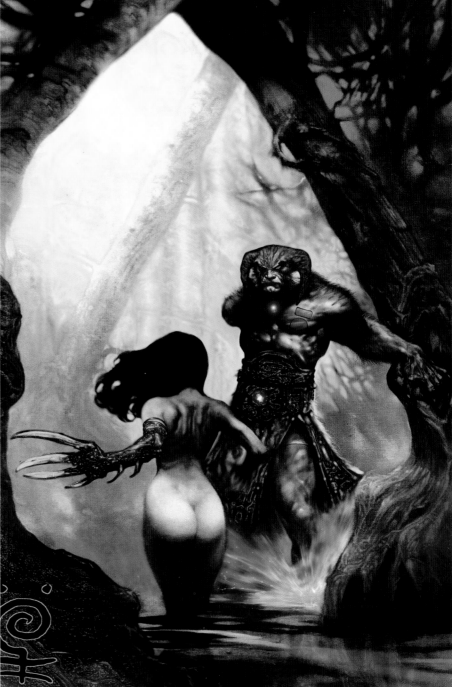

▶ Battle babe

Corlen Kruger

This heroine is brave and defiant, and if her feminine form suggests vulnerability, her costume, particularly her fearsome breastplate, belies this. Striding upward with a look of determination, she is clearly ready for battle.

So how do you go about developing a style? Well, the first thing to do is to work out your strengths. The chances are your strengths are similar to the styles you've been inspired to try to emulate anyway. Once you've done this you can experiment with other styles and just add your own personal touches. When you get more competent at drawing you can branch out and broaden your style. The sorts of styles you should try to follow are the ones that especially appeal to you.

high fantasy

Think big when working in this subgenre. Everything should be as exaggerated as possible, from the hero's rippling muscles to the weapons belt he carries, which should bristle with armoury. The girls wear very little – perhaps a leather bikini – and show plenty of cleavage.

▶ Killing machine

James Ryman

This physique has been customised for destruction. A broad chest helps to support massive shoulders and vast cybernetic arms, and the whole colossal form is kept alive by way of an inorganic ventilator. The one visible green eye does much to convey the sense that this is a malevolent and fundamentally inhuman creature.

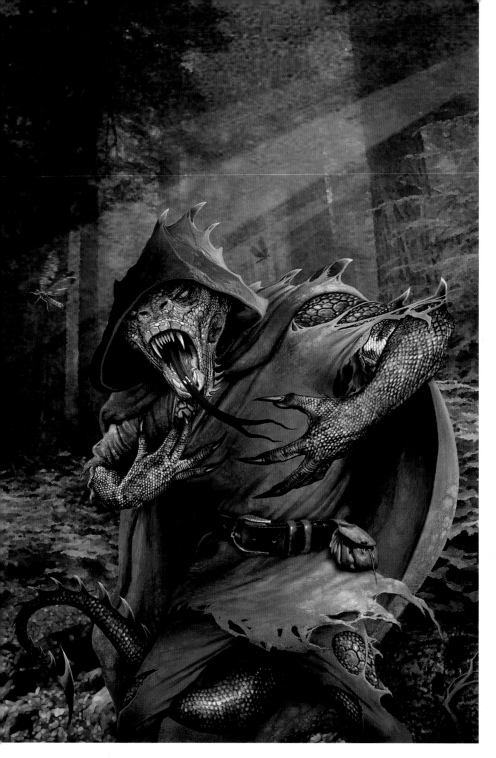

◀ **Lizardlike humanoid**

Martin McKenna

From a distance, this cloaked and hooded creature might appear human, but the serpentine tail and scaly skin are a giveaway. Musculature is hidden beneath horny scales and inhuman extrusions that line the spine and form a crest on the skull. With snakelike teeth and long, strong claws, this character doesn't need any extra weaponry; its physiology is deadly enough.

▼ **Murder in mind**

Martin McKenna

This is a study in how much malice facial features can convey. The flared nostrils, heavy furrows and ridges around the nose, eyes and brow indicate a face that has not smiled much, except maybe in delight at the carnage it has caused. This is a monster with murder in mind, and if its blade doesn't kill you its sharpened fangs will probably finish the job.

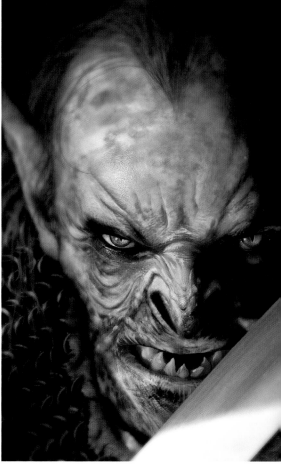

space opera

Most fantasy takes place in worlds utterly different from our own, or a fantastical version of our own world. This world could be in another time and another space. It's peopled by alien creatures and vegetation, but several of the inhabitants retain recognisable humanoid forms.

the weird

Fantasy illustrators are always looking to unsettle their viewers. They want to present a fractured world view, one that will solicit a gasp or a double take. You – the viewer – want to look closer, but sometimes the imagery is too disturbing to warrant close examination.

▲ **The beautiful goat woman**
Keith Thompson
There can be no mistaking the fantastical appearance of this creature. Her beautiful human face engages the viewer, but her hoofed satyr legs and tail soon reveal her otherworldly aspect.

▶ **One deadly knight**
Keith Thompson
Stylised and highly idiosyncratic, the armour suggests something of the wearer's personality. He is obviously important, probably powerful, and has a taste for the baroque.

arcadia

Arcadia is the world of enchantments – the magical land – where the reader really can believe in fairies. In this bucolic paradise, brave knights fight dragons, and fair damsels fall under the spell of evil witches.

▶ **Playful fairy**
Matt Hughes
A character you would most expect to find in an enchanted land, this fairy looks sweet and appealing. But for all her charm and smiles, beings from this realm are usually mischievous and unpredictable. Her coy yet inviting pose should be viewed warily.

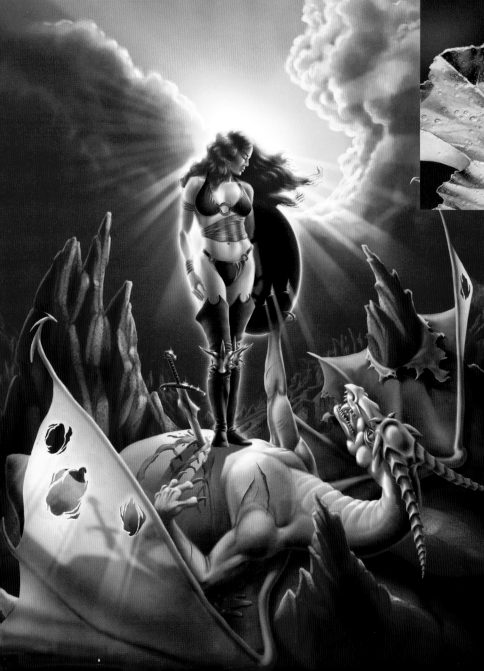

◀ **Death of the dragon**
Jose Pardo
The rays of light streaming from behind the woman warrior's fiery red hair seem to confirm her victory over her opponent, but this image is not static – the dragon, still aggressive even in the throes of death, has grasped her shield.

Beauty and gentle eroticism are at the heart of this image. The simple, silken garment that covers the curves of her body clings lovingly to her feminine contours, creating a potent image of distinct yet untouchable sexuality.

▼ **Essence of erotica**
Maurizio Manzieri
The girl's arms and legs are smooth, with little or no muscular detail. This enhances her femininity and increases her sexual allure.

erotica and exotica

What characterises this art is undressed women (and sometimes men), and some pieces of hardware (like a motorbike), or an exotic animal (like a unicorn). Clothing decorates, reveals and caresses the body.

Fantasy artist's
master class

When you are creating a fantasy scene, literally out of this world, your job is to make something unreal look totally convincing. Central to the discipline of fantasy art is the imagination combined with a good grounding in anatomy. This will free you not only to create convincing representations of ordinary people but also to explore inventive anatomy, and to render the unbelievable believable.

Having shown you how to structure your figures, this section then looks at how to bring them to life with movement and characterisation. The effects that can be achieved with lighting and perspective will help you to dramatise your characters.

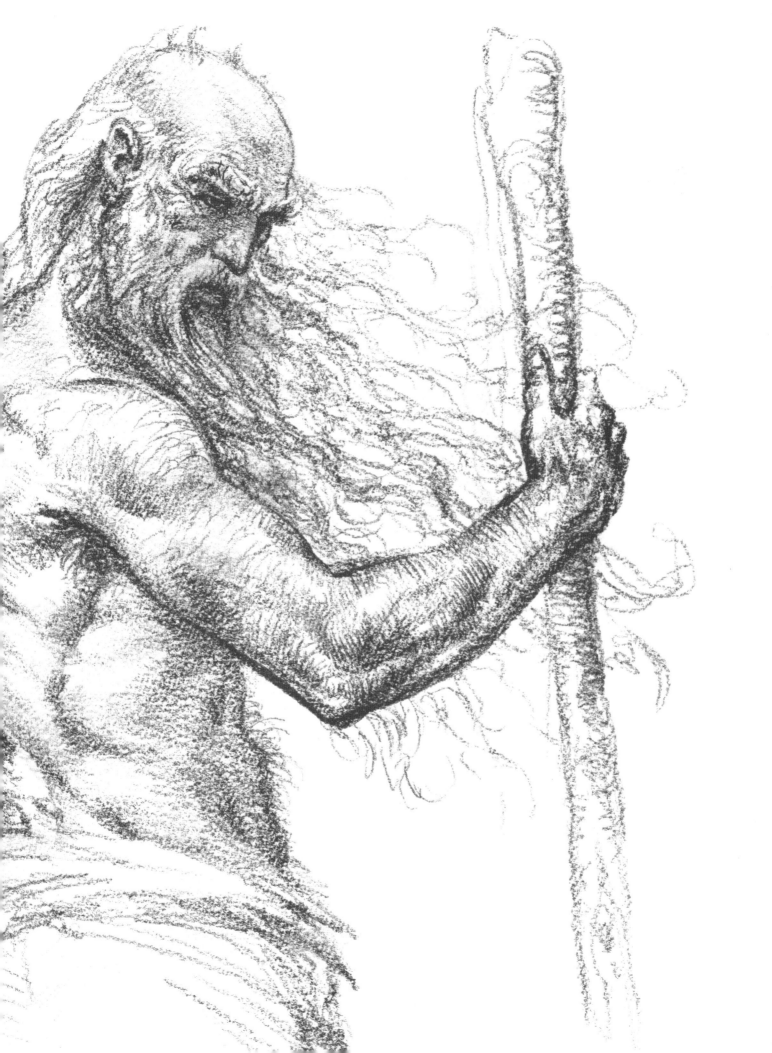

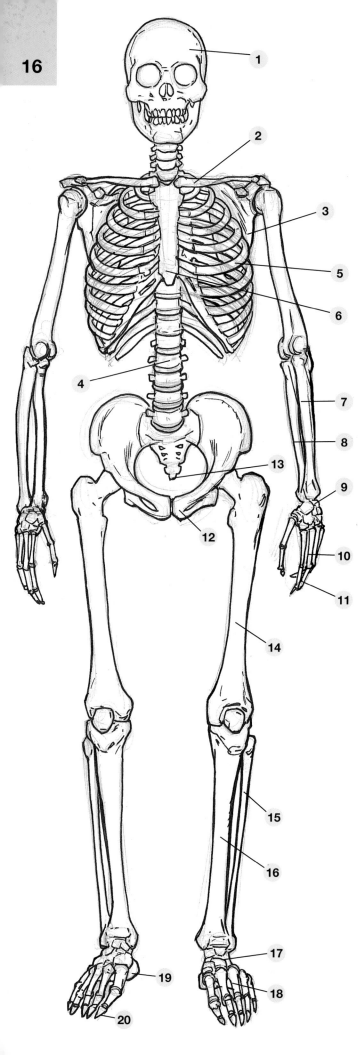

Human skeleton

Almost all fantasy illustrations, no matter how otherworldly their settings, contain human figures – or, at least, distorted human figures. The human skeleton is where every fantasy character begins: the bare bones. Don't panic. You don't need to draw a full, anatomically correct skeleton every time you want to create an illustration, but a little know-how about its make-up and proportions and a few artist's tips will go a long way.

from the front

This is a completely average human skeleton – the base against which all others are measured. It's about seven heads tall, with shoulders approximately as wide as the hips, and hands that fall mid-thigh. The pelvis is just over half the way up, with the legs measuring about four heads high, and the torso about two. You'll learn how to simplify and adapt the basic skeleton to fit all the different fantasy archetypes later, but for now it's a good idea to familiarise yourself with its basic composition.

It's important to pay particular attention to the structure of the hands, for several reasons. Not only are the hands among the most intricate parts of the whole skeleton, but the hand bones show through the skin more than any other area, and are thus responsible for the shape and position of the digits.

the main bones

1. Skull
2. Clavicle or shoulder bone
3. Scapula or shoulder blade
4. Vertebrae or spinal column
5. Ribs
6. Sternum or breastbone
7. Radius
8. Ulna
9. Carpus or wrist
10. Metacarpus

11. Phalanges (14 finger bones)
12. Pubic bone
13. Coccyx
14. Femur or thighbone
15. Fibula
16. Tibia
17. Tarsus or anklebone
18. Metatarsus
19. Calcaneus
20. Phalanges (14 toe bones)

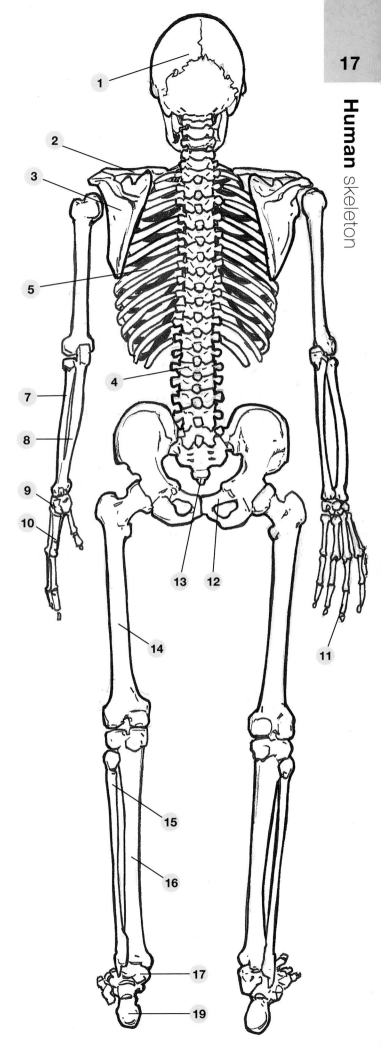

▲ **Skeleton slayers**
Skeletal characters have immediate, grisly impact. They are the undead, and it is obvious that their powers lie purely in the supernatural.

from the back

Here you can see how the scapula helps to make the shape of the shoulders. Notice also the shape and position of the skull. Its characteristics are not usually used to map out the facial features so you don't need to remember their exact locations, but a good knowledge of the overall shape is essential for drawing heads that look realistic.

The vertebral column is another area that obviously affects the surface of the skin, so a close look at how the vertebrae sit together will be helpful later on when you come to shading the skin of your character. Don't worry if you can't memorise the name and position of every bone just yet. They will become a lot easier to remember when you've drawn them a few times, and you can always refer back to these images to see what goes where.

from an angle

This illustration gives a better idea of the three-dimensional shape of the skeleton.

skull

Don't forget to have a good look at the skull, too, particularly noticing here how it joins to the vertebral column.

clavicle and rib cage

See how the clavicle and scapulae fit like a yoke that slips over the neck and rests on the round mass of the rib cage.

Simple shapes
The skull, rib cage and pelvis are all represented by primitive, simplified shapes.

spine and pelvis

The box shape of the pelvis bears the weight of the spine, and the two together form a series of joints held by ligaments that allow the body to bend and twist.

carpal and tarsal bones

You get a good view of the carpal (wrist) and tarsal (ankle) bones here, so take this chance to really get familiar with them – you'll be glad you did later when you're drawing amazingly realistic hands.

Positioning
See how the hands and feet are simplified – this is just for positioning, so you can go back later to give them more shape.

convincing posture

When constructing a fantasy character, making a complete drawing all at once is difficult. Hardly anyone does this, not even the world's top fantasy artists, simply because it is much more effective and simple to construct a figure in stages. The first stage is, of course, the skeleton, which is then used to establish posture, proportions, position and action.

The skeleton acts as the framework for your final rendering. Everything you draw from now on will be positioned around this structure, so it's vital to draw the skeleton in a position that looks comfortable and natural. But you don't need to draw a highly-detailed human skeleton every time. Most artists find that a simplified version, such as the one shown here, is a perfect way to quickly start assembling a character. If you turn to the gallery section on page 64, you can see how other artists simplify their skeletons.

Representations
The bones in the arms and legs don't affect the shape of the skin directly, so they can be represented as lines or "sticks".

Practise
Now all you have to do is practise until drawing skeleton models becomes second nature. This stage is vital in terms of creating a position that looks natural, so keep going until you can draw every pose with every set of proportions imaginable.

male

female

Human
musculature

Once you have a grasp of the skeleton (see pages 16–19), you need to learn how its supporting and covering musculature is structured, because this gives the body its substance. Musculature is where exaggeration plays its most important role in setting the fantasy human-based form apart from the everyday human form – powerful warriors need highly developed muscles in order to look convincing. However, in order to work, an exaggerated fantasy image needs to be grounded in truth.

from the front

From the broad pectorals to the powerful thighs, the front of the body is swathed in a complex segmented shell of bunched muscles. Together they act in conjunction with the spine, supporting the skeleton, as well as the internal organs. The thick ribbon of powerful abdominal muscles clings to the underside of the ribcage and stretches to the groin and the tops of the thighs. It is designed for the anticipation, and release of, action.

the main muscles

Front
1. Trapezius muscle
2. Deltoid
3. Pectorals
4. Obliques
5. External obliques
6. Adductors
7. Vastus muscle group, and the rectus femoris
8. Sternomastoid
9. Triceps
10. Biceps
11. Flexor carpi radialis
12. Flexor carpi ulnaris
13. Abdominals
14. Extensor digitorum
15. Triceps surae
16. Peroneus longus

Back
1. Trapezius muscle
2. Deltoid
3. Rhomboideus muscles
4. Latissimus dorsi
5. External obliques
6. Gluteus maximus (buttock)
7. Biceps femoris
8. Peroneus longus
9. Triceps
10. Gluteus medius
11. Triceps surae (calf)

▶ *In this dynamic sketch, the detailed muscles seem to ripple, and enhance the sense of motion.*

from the back

The muscles of the back, spine, pelvis and legs are the solid foundation of the whole body's muscular support structure. The delicate vertebrae of the spine are held in place by leaves of supporting muscles, which are in turn swathed in layers of broad, strong muscle. The shoulder blades are held in place by bunching triangles of muscle that give the shoulders their imposing strength, while those of the calves really inject the power into running and leaping.

differences between male and female musculature

In general, male musculature is much larger than that of the female. The muscles of the male tend to ripple and bulge with definition, and are very large and visibly structured. Pectorals and deltoids are broad and powerful and the abdominals are very well defined. The female musculature is much more lithe, with softer contours and less definition, especially in the stomach and rib areas.

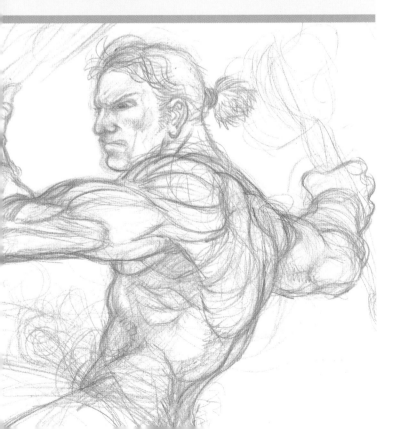

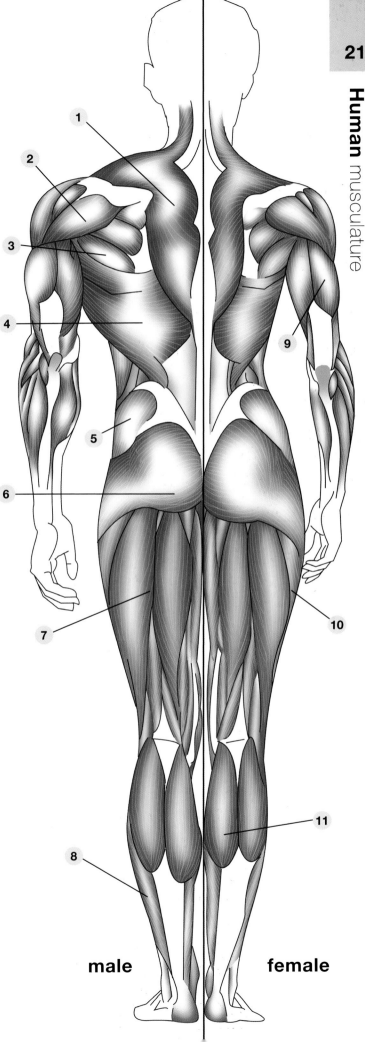

male female

muscles in action

It is essential to understand how muscles work in motion. Exciting art begins and ends with action, and to that end, bodies must be stretched and pulled into any number of realistically rendered positions. When in motion, muscles take on new shapes that are sometimes surprising: some grow, some shrink and others seem to appear as if from nowhere! Although a lot of attention is usually given to the obvious muscles such as biceps, pectorals and abdominals, lesser noticed muscles, such as the triceps and buttocks, become much more obvious when exerted.

in combat

In these images we see both defensive and offensive action. The male attacks with determined force, power and direction. The female reacts by simultaneously moving away with her lower body while delivering a counterattack with her torso and arms.

5. Both these bodies are held taut and prepared for action by the front and back muscles of their torsos. The abdominal muscles are flexed and defined.

6. The upper and lower sets of arm muscles have the job of pulling and pushing against each other in order to bend and straighten the arm, while the biceps and triceps create the power to carry out forceful actions.

7. The muscles of the forearm are bunched as the hands grip the axe handle.

8. The deltoids are the primary source of power for the male's axe-weilding.

9. The vastus lateralis (back of the thigh) and gluteus maximus (buttock) muscles bulge, straining to counterbalance the weight of his axe. The bunched posterior thigh muscles will provide the drive and strength to power the next action.

1. When thrusting the bow forward, the power is delivered from the shoulder.

2. Even when flexed straight, the triceps bulge.

3. The female has less angular definition than the male, and her form is much more rounded and smooth.

4. Held out straight for balance, the muscles of the calf lie relatively flat.

the head

The muscles of the head are largely responsible for defining the facial features and supporting the jaw. For example, a threatening and brooding barbarian might have large bunches of knotted brow muscles hooding his eyes, as well as bulging jaw muscles and a broad neck. A trimmed down musculature helps to define the finer features of the female visage. Facial muscles can be distorted in any number of ways to create a bewildering range of facial expressions.

Human musculature

muscles of the face

1. Temporalis
2. Frontalis
3. Compressor naris
4. Orbicularis oculi
5. Quadratus labii superioris
6. Zygomaticus major
7. Masseter
8. Depressor anguli oris

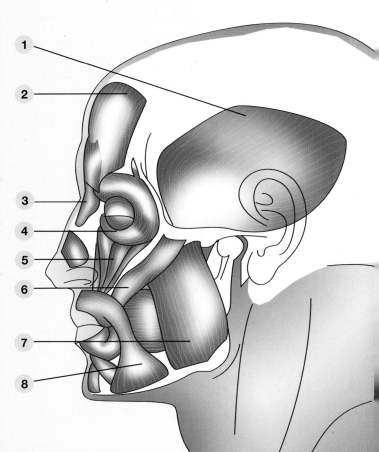

10. Having just delivered the surge of power for the upward leap, the calf muscle bunches up as the leg bends, bulging with stored energy for use when the leg is straightened once again.

11. The front or anterior muscles of the thigh are stretched taut as the knee bends and the lower leg pushes back and up. These muscles will be used to pull the leg straight again.

Facial expressions

The face is by far the most expressive part of the body, and as such you will need to make absolutely sure your expressions are clear and comprehensible. Don't be afraid to exaggerate your expressions to the limit, in keeping with the general theme of fantasy art! A bold, clear expression is not only easy to decipher, it is also striking and exciting. Small glitches, such as an unintentionally raised eyebrow or corner of the mouth, can be misleading, and give your character's expression subtle nuances which may be confusing, or just look bad.

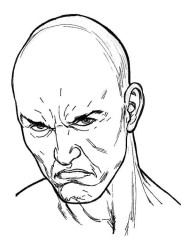

▲ Sinister

The brow is furrowed and the eyes half closed, but here the downturned mouth and the position of the head make the character appear more sinister and thoughtful.

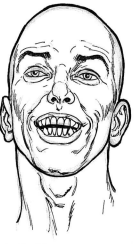

▲ Smiling

Here we can see our character's teeth, which would usually be interpreted as a show of aggression in nature. However, the relaxed eyes with raised eyebrows, and the specific shape of the mouth tell us that our character is blithe and calm.

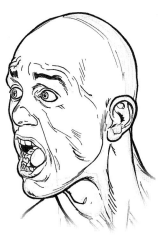

▲ Confused

Most of the basic human expressions are symmetrical, so when we get one like this we know there must be quite a sophisticated specific emotion behind it. The raised eyebrow and corner of the mouth coupled with the sideways stare tell us our character is either confused or disgusted about something.

▲ Shocked

This expression is unmistakable. By simply opening the eyes and mouth as wide as possible, raising the eyebrows, and focusing the stare straight ahead we get a striking impression of shock and amazement.

rendering the face

Notice how a knowledge of anatomy lets you create an expressive face, from one that's detailed and fully rendered to one that's much simplified, using colour detail to express the emotion.

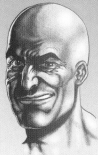

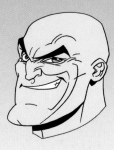

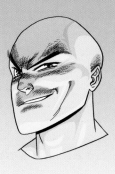

Fully rendered face

Pastiche lantern jaw

Simplified using cross-hatching for shadow

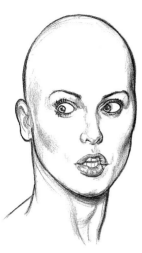

◄ The female face

The differences in features between male and female characters are immediately distinguishable. Whereas a male's features are generally large and slightly crude, a female's tend to be smaller, with more finesse and contrast in colour. Notice how fine the eyebrows are, how well the eyelashes stand out and how defined the shape of the mouth is.

► Gritted teeth

In fantasy art it's generally assumed that female characters are more thoughtful and less aggressive than males. Here the exaggerated shape of the mouth and slightly raised eyebrows give the character's otherwise angry visage a sassy twist.

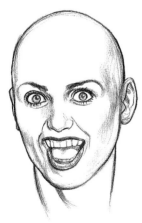

◄ Smiling

Notice how the mouth retains its smile even though it's open wide. To make sure you don't end up drawing something you don't want, be patient and use your mirror to figure out which subtle nuances will give your character the desired expression, and focus on getting those just right.

► Sideways glance

Drawing a relaxed expression from a commonly used viewpoint is as useful as drawing an extremely unusual expression from a very abstract angle, and it's always a good idea to make sure you're comfortable with the basics before you move on to more complicated approaches.

shorthand faces

In this exercise, you can see how developing a shorthand approach can help capture the essence of an expression. This can then be built up to a fully rendered face.

anger *joy* *surprise*

fear *sadness* *disgust*

building a face

This sequence shows how the shorthand example perfectly captures the essence of an angry face. Compare the rendered example with the shorthand version and note the similarities.

Face reduced to key characteristics—deeply furrowed brow, eyebrows about to take off.

Artist sketches in details, giving emphasis to the most important features.

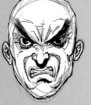

More detail added – wrinkles appear across the forehead and the cheeks start to bulge.

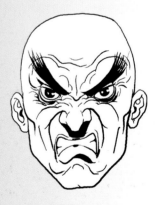

The fully rendered face – eagle-wing eyebrows in full flight, and anger seeping from every pore.

Expressive hands

Here's where you really have to get to know your skeleton, because the shape of hands is dictated almost entirely by their bones. Muscle groups rarely have any definition because, although maximum dexterity is a must, strength is relatively insignificant, and bulging fingers look bizarre and move badly. The shape of the fingers can be affected by additional fat, but this can be added as it would be for any other part of the body, so on these two pages we will focus on a standard, slim pair of hands.

The thumb is attached at a large joint positioned close to the wrist.

▲ Closed hand

Part of the reason why the bones affect the shape of the hands so much is the sheer density of joints (14 just for the digits). See how the skin bulges very slightly at each joint, especially when it is bent, and how the fingers taper towards the ends, although this is only really noticeable when they are held together.

◄ Back of hand

The back of the hand can be a difficult area to draw because there are so many details – knuckles, fingernails, joints – all of which can vary greatly from person to person. Think about how the character's body is reflecting its personality, and how best to use the hands to reinforce this.

The finger bones extend beyond the knuckles into the back of the hand.

The fingers taper towards the ends, but widen out at the joints.

◄ Open hand

For a clearer image, shading is kept minimal, whereas bold lines are used to highlight folds in the skin. Getting the proportions right is essential, so you'll need to refer to your own hands constantly. Remember, the only way to learn to draw anything properly is to practise. Hands are notoriously difficult, so don't lose patience if it doesn't look right immediately.

Looking at the shapes in between the fingers helps you to get the fingers right.

▲ Half-closed hand

To make the hands extra dramatic, make them more angular and increase the tightness of the skin. Experiment with your own hands to learn how different positions can produce various effects.

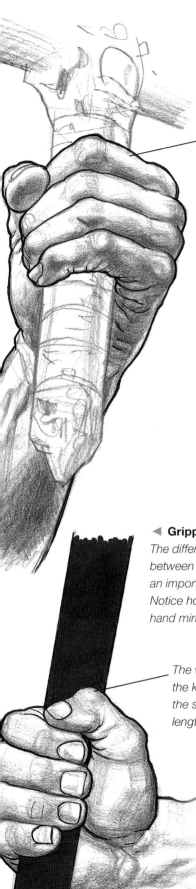

The fingers are about half the length of the whole hand.

◄ Gripping hand, left
Close observation is the only way to understand all the complex movements of the hand. Notice in particular the way in which each finger has its own movements, especially when curled to grip an object.

◄ Gripping hand, right
The difference in perspective between the right and left hand is an important aspect to get correct. Notice how the movement of each hand mirrors the other.

The width across all the knuckles is about the same as the length of the fingers.

► Alien hands
Liam Sharp
Even though these hands are otherworldly, they are still informed by a knowledge of human hands. As long as fingers continue to bend at knuckles and joints, and hands continue to grasp, you will be able to use your anatomy work to create more plausible fantasy hands.

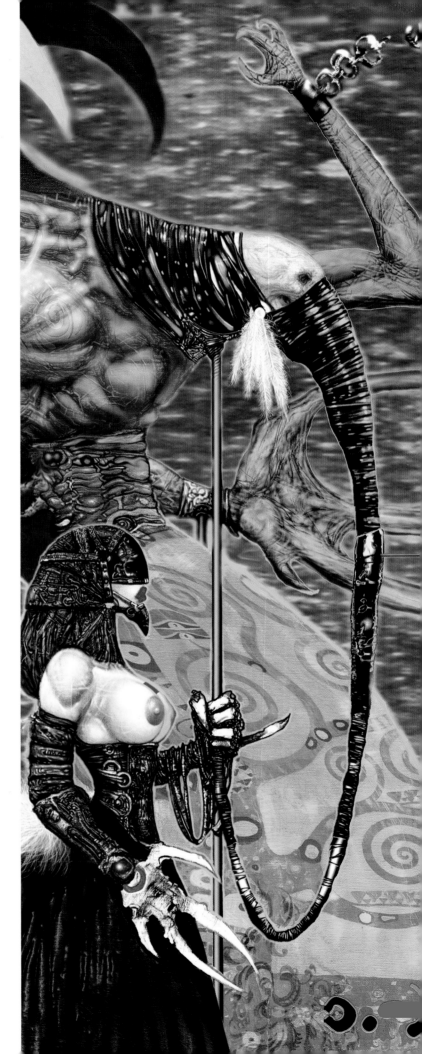

Body language

In real life we convey almost as much through our bodily posture as we do through the words we speak and the tone in which we speak them. The ways in which people move give a key to their characters and even their occupations. Don't be too frightened of making your characters perform exaggerated, actorish gestures, either. Remember, you're giving the viewer visual clues, not accurate depictions of reality. In a way, fantasy art is performance art.

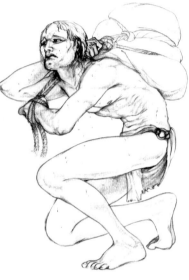

▲ **Suffering**

The character's crouched stance, emaciated form and pained expression give a real feeling of weakness. Details such as the sack and his flat, lank hair really add to an image.

deciphering poses

In these sketches, Ron Tiner has used a combination of body language and physical character types to give very different meanings to the same simple phrase.

▲ **Victor and victim**

Her firm stance and strong, straight limbs contrast with the monster's contorted, uncontrolled movements as he angrily struggles to escape.

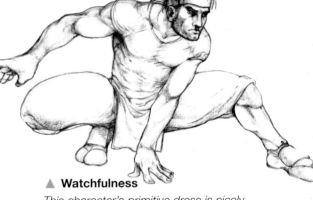

◄ Attack
Although this posture would not normally be advisable for delivering a punch, it incorporates a nicely puffed-out chest, a chilling downturned face, and an interesting leg arrangement which shows off the character's broad build nicely. Remember, arrange your characters for impact, not practicality!

▲ Wrath
This character is erupting in sudden, furious movement so that he appears coiled and compact, springing up from an inner core of bundled energy. The sense of upward motion is confirmed by his eyes, peering up from beneath hooded eyelids. His fists are clenched to deliver a powerful blow with all of his momentum behind it.

◄ Terror
The way in which our character attempts to shelter his face with his hands, and appears to be in full flight, truly sets off his terrified facial expression. His uncontrolled and erratic movements are a great window to his mindset.

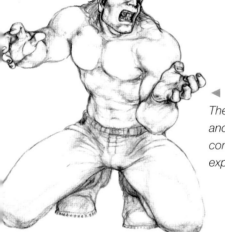

◄ Anger
The character's contorted posture and crooked hand gesticulation complements his furious facial expression.

▲ Watchfulness
This character's primitive dress is nicely accompanied by his primordial choice of stance, which references heavily from many of nature's predators – a low, light-footed crouch ready to spring into action at any moment.

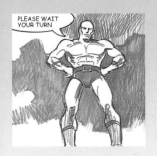

All the lines of this huge individual's body tell you you must wait your turn. There can be no arguments.

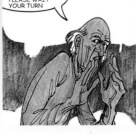

The floppy, lank hair enhances the impression of someone who is not demanding but humbly requesting.

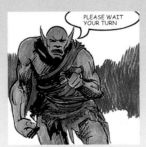

This character is telling you that, though you might argue with him, he would rip your head off if you did.

With a flamboyant gesture, a wizard tells you to wait your turn – and there is no question but that you will.

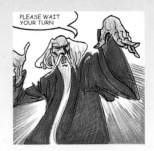

Clothing the figure

Clothing is the most immediate visual indication of character. In fact, "costume" is a better term, as clothes and accessories influence a character's actions and poses. Strong colours indicate boldness and power; softer colours can signal gentleness or weakness. Females usually wear garments that accentuate their feminine form, and superheroes dress in a way that emphasises their strength.

▲ **Archetypal armoured warrior**
Every part of his body is hidden inside this forbidding metal carapace, apart from his glowing eyes. Medieval detail around the shoulders, and a big billowy cape add to his size. This is a highly structured costume, and your knowledge of anatomy is just as important here as for more minimal outfits.

◀ Fighting female

Her tight clothing gives her minimal covering, and where it does cover her, it serves to accentuate her physique rather than to conceal it. Black leather and high boots give this character the air of a dominatrix. Note that make-up can also be used to dramatic effect.

▶ Thief giant

His costume tells the story of his pillaging, for which he clearly roams far and wide. Why wouldn't he use a tree for a club or strap a cannon on his wrist? If it can be drawn, draw it. But keep your inventiveness convincing – see how the artist has kept to a consistent scale.

▲ Corsets and ribbons

This character sports an elaborate reworking of the traditional fairytale bodice and dress with an eerie edge, achieved with an unusual use of secondary motion – are her clothes moving in some wind, or do they have a life of their own?

◀ Celtic superhero

His tartan trousers and cape mark him as a Celtic hero, but he also has overtones of punk rock and heavy-metal fashion – a device used by the artist to help him appeal to his target audience. His cape, flowing behind him, throws his physical strength and solidity into relief, and the effect is majestic.

Character and body types

Using specific body types when drawing fantasy figures helps to give visual pointers to the type of character you are portraying. The body shape classification system (somatotyping) recognises three main types: mesomorph, ectomorph and endomorph. Use your knowledge of these types with care, giving individual anatomical details to your creations.

◀ **endomorph**
1. Softly rounded shape
2. Large belly
3. Small hands
4. Fleshy overall appearance

These figures have a hefty, rounded build, with a tendency to become fat. Sumo characters are a perfect example. Endomorphs are used much less often than either mesomorphs or ectomorphs, and commonly appear as secondary characters, usually on the side of evil, in roles where the novelty of their size is fundamental.

Endomorphs can be difficult to draw because their shape is almost entirely dictated by the way their fat distributes itself. This distribution can vary during movement – fat is not anchored to parts of the body and can move around freely.

hair

The pattern of hair on a character's face and skull can be used to convey personality. Look at the thumbnail sketches shown here of stock faces given different types of cranial and facial foliage. Curly hair can make someone look frivolous; straight hair tied tightly back can make a character seem self-controlled, perhaps even icy or uncommunicative. Straight hair swept back off the forehead can be used to make someone seem arrogant or bombastic, but add glasses and that person can seem severe or intellectual instead.

◀ *Tied sleekly back, then erupting in a tangle, her hair promises that beneath her civilised exterior she's a wild child.*

◀ *Choppy, wavy hair makes a character seem fun or frivolous.*

◀ *This natural style tells us that she has more important things to think about than her hair.*

mesomorph

1. Heavily boned
2. Compact, robust, square body
3. Well-developed muscles

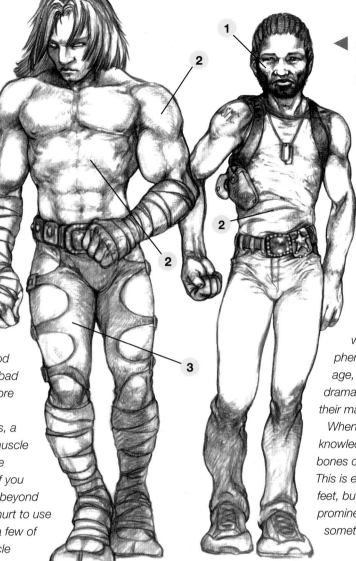

Traditionally, heroes are of this construct, with a compact, robust, muscular body. It makes for good strength and agility, and it is an attractive aesthetic quality (one that people will admire or desire). In fantasy art a fit and healthy muscular body is associated with the good male protagonist, whereas the bad character usually has one or more physical defects.

When drawing mesomorphs, a good knowledge of the basic muscle groups is essential, as these are always large and well defined. If you want to enlarge your character beyond the realms of reality, it doesn't hurt to use a bit of artistic licence, adding a few of your own complementary muscle groups around the larger ones.

ectomorph

1. Fragile-seeming features
2. Minimal flesh and muscles

These figures are light and slender. Characters who usually fall into this category include females with magical powers, nymphs, vampires and aged wizards. Attractive female characters appear in ectomorphic proportions, as they normally rely on agility in physical combat, and slenderness in a female is generally regarded as a desirable quality. However, wizards have an emaciated phenotype to promote the illusion of age, and to produce a more dramatic effect when they unleash their magical powers.

When drawing ectomorphs, knowledge of the skeleton is crucial, as bones can be visible through the skin. This is especially true of the hands and feet, but the skeleton can also be prominent in the back, the rib cage and sometimes even the pelvic area.

◄ *Hair swept back off the forehead and clipped sideburns extending to the jaw give a stylish, brooding look.*

◄ *An intellectual, often sinister look can be gained by giving your character a beard and a bald pate.*

◄ *Romantically shaggy hair that curls around the ears gives him the air of a poet.*

facial flesh

Whatever the basic facial shape, you can alter character by adding facial fat. There are five primary locations where it appears: (1) the side of the nose down to the corner of the mouth; (2) around the jowls; (3) on the chin; (4) beneath the chin; (5) under the eyes.

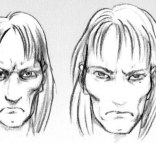
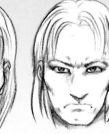
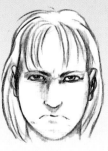
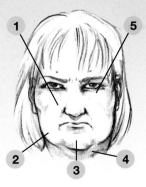

Figure reference file

This section provides you with some useful reference without the hassle of having to pay a model to sit for you. Remember, if you're working from other photographs – from magazines, say – that all published photographs are the copyright property of the photographer. If you don't own the copyright to a photograph, don't base your artwork on it, though you can use it as a springboard for your illustrations. Of course, you are free to use the photographs in this section in whatever way you wish.

There's a wide range of positions, poses and moods, categorised under five headings: classic figure drawing poses; classic details; superhero poses; female fantasy figures; and archetypal villain poses. You could try to put some of the figures together to create a group pose. Or you can create composite figures by taking elements from different poses and mixing them together. The starting point is to make sketches, and plenty of them.

classic figure drawing poses

Fantasy figure illustration relies on realistic body form and poise. To capture this, it is essential to study classic poses. When limbs stretch or bend, or the back arches, muscles behave in very particular and often surprising ways, and you must bring a solid understanding of this to your drawings.

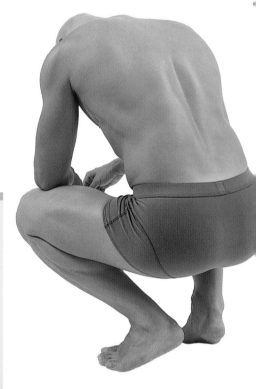

▼ **Reclining female**
The back is arched and the arms reach back to cradle the head, accentuating the slim waist by stretching the stomach muscles. The raised leg is visually balancing, counteracting the extended foot.

1. The backs of the arms are stretched and taut, whereas the biceps and insides of the forearms are relaxed and softly bulge.
2. The extension of the body pulls the stomach muscles into a smooth, flat shape.
3. The front of the bent thigh is smooth and taut, with the back of the thigh relaxed and curved.

◀ **Seated female**

The centre of balance is quite far back in this pose, so the arm in full extension is used as support. The triceps bulge to take the strain. This is a relaxed pose, with the head tilted slightly to one side stretching the neck muscles, and the small waist and smooth leg outline maintaining a feminine aspect.

◀ **Hunched male**

The back is elongated and stretched as the head is lowered and the upper legs are brought forward. The vertebral column is visible on the surface of the skin at the top of the back. The heels are slightly raised off the ground for balance, which is maintained as the arms rest on the knees.

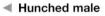

3

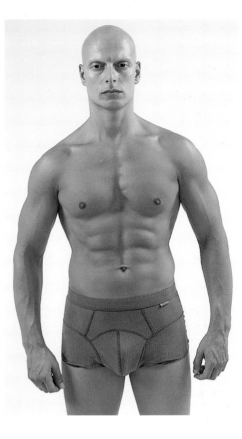

▲ **Male front view**

The chest and shoulders are broad and well defined, whereas the waist is pinched, and the abdominal muscles are relaxed. The neck is as wide as the head, and the features are stern and sharp.

◀ **Female standing**

The right leg is taking the main body weight, so it is straightened. The left leg is bent and gives the hips a diagonal slant. The shoulders mirror the hip line with a contrasting diagonal as the right arm dangles loosely, and the left arm is lifted up to rest on the waist.

classic details: upper body

The upper body is the powerhouse of the fantasy physique. Strong, well-defined muscle structure over well-proportioned bones underpins any powerful hero or villain.

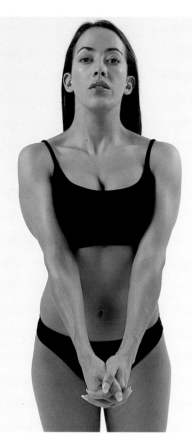

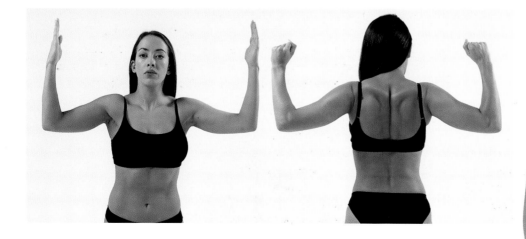

◄ Female torso and arms

The arms are straight and locked at the elbows, causing the triceps to bulge and pushing the breasts together. As the hands push downward, the chin lifts and the head tilts back, which makes the neck bulge a little.

▼ Female torso front

A good pose to illustrate proportions of the arms, head and upper body. The shoulders are pronounced, curving smoothly into the arms, and the flat stomach is subtly defined.

▼ Female torso back

As the arms stretch the chest, they simultaneously cause the shoulders to contract, creating pronounced ridging of the back muscles.

▶ Male torso front

The torso leans forward and the head is lifted, enhancing the powerful musculature of the neck and shoulders. The arms are held close in to the centre bodyline, causing the pectoral muscles to bulge. The forward position of the body also causes the abdominal muscles of the stomach to bulge slightly.

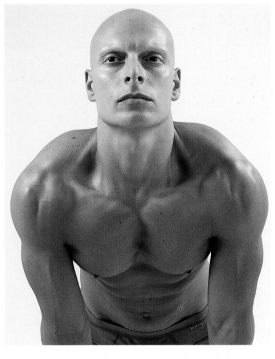

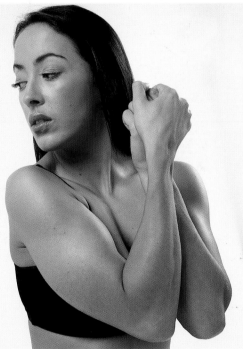

▲ Female arms

The fists grip together and the arms are pulled towards the head, causing the muscles to bulge.

▲ Male torso back and arms

The biceps bulge and the triceps are stretched taut as the forearms punch upward to strike a classic "strong man" pose. The back muscles bunch together, creating a defined line down the centre of the back, and the diagonal shoulders cause a couple of wrinkles at the waist.

1. The forearms are powerful and defined as the fists curl inwards, and the upper arms are held at right angles to the body.
2. The shoulder blades bunch together, defining the back muscles.
3. The bicep contracts and bulges as the arm bends, and is slightly smaller than the bulge of the shoulder.
4. The buttock muscles, or gluteus maximus, are firm and tight.

classic details: lower body

This area of the body helps to underline the sexuality of the character, so females need a flaring pelvic girdle and rounded hips leading to long, lithe legs, whereas males require bulging legs rippling with corded muscle.

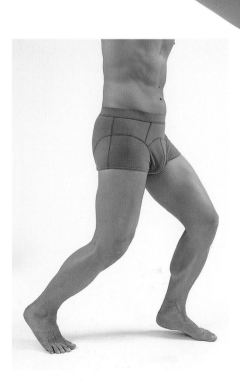

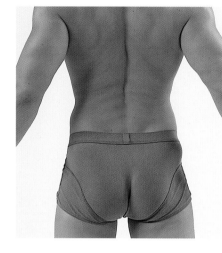

▲ Male back
The ribs curve slightly down from either side of the spine, and the muscles essentially follow this downward swoop, especially in the lower back.

◀ Feet underside
The outside of the foot curves smoothly towards the little toe. This contrasts with the instep, which is between the slim heel and the broad ball of the foot.

◀ Female legs
Classic female legs are long and slender, with little muscle definition and few sharp extrusions; every aspect of the female leg is about long, flowing lines and soft features.

▶ Male legs and side
There is a definite dip just before the rear leg muscles bulge out and down to the back of the knee. The front of the upper leg has a slight convex curve connecting with a sharp knee, which can be quite pronounced. The calf muscles bulge before dramatically cutting back into the leg line as it leads down to the heel.

► **Female back, bottom and legs**
The behind is round and broad, before curving inward towards the knees. The calves taper to the ankles in gentle curves. The waist is accentuated by the balance of the figure mid-step, all the body weight being placed on the left leg.

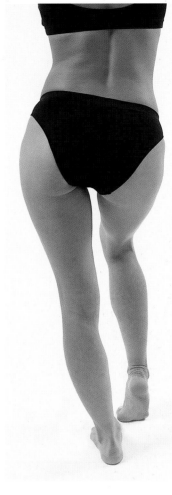

◄ **Classic seated female**
The hips flare out from the slim waist, accentuated when the knees are brought up. The curve of the hips is continued with the long, tapering thighs. The knees are smooth, the lower legs have a soft outline, and the feet are typically quite petite.

1. The arms extending behind the body pull the breasts outwards, increasing the breadth of the upper body.
2. The hands are smaller in relation to the arms than the male's, and have no sharp knuckles or protruding veins. The fingers are tapered.
3. The bottom is large and rounded, and should be a little wider than the upper body.
4. The lower legs are slim, and taper to meet the feet.
5. Like the hands, the feet are smaller in relation to the legs than the male's, and have no protruding veins.

► **Female hips and legs**
The hips are angled diagonally from the spine, accentuating the slim waist. The right leg bends while the left leg is straight to support the body. There are no extreme edges or angles; instead, the whole body curves gracefully from one area to the next.

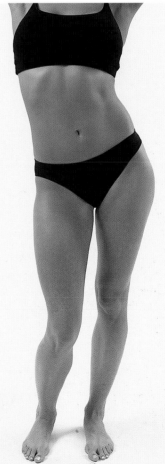

3

4

5

superhero poses

Fantasy heroes are not ordinary characters, and their posture should reflect this. They should be rendered in dynamic poses full of power, forcefully directed energy and furious vigour!

▶ Jump
This is an attack jump, where the leading leg is extended to deliver a strike. The forward leg is straight, and the trailing leg is curled back and streamlined.

▼ Backward sword
This pose suggests a sword or spear held at the neck of a vanquished opponent. Every muscle is taut and defined, suggesting that our hero has been engaged in a strenuous physical battle.

◀ Victory
Once again successful in battle, the mighty hero raises his muscled arms and shouts his victory to the heavens!

▶ Scaling a wall

Viewed from beneath, we see the gripping hands and arm muscles taut with the strain of clinging to the wall. The leading left arm is balanced by the raised right leg.

3

▲ Flying

The leading arm is outstretched, indicating powerful forward momentum. The other arm is streamlined, held close to the side. Just after the moment of liftoff, the left leg is still bent for balance.

◀ Punch and grab

Here, dynamic poise and elegant mastery of fighting technique is the theme as he pushes against an object with his right arm to strike out with his left.

1. The features are severe and well defined – the "chiseled" looks of the traditional hero.
2. The fingers look powerful, and the tendons and veins protrude as the hand grips and pushes against an object. The backward motion of this hand balances the forward motion of the left hand.
3. The pectoral muscles are pulled taut as the arms reach both forwards and backwards.
4. To add extra power to the punching arm, the opposing leg is thrust forwards, transferring motion and energy up across the back and through the shoulder.

▶ Sword coming down

The extended arms stretch the chest and stomach, and the muscles are clearly defined as a result. The raised leg counterbalances the sword held behind the body, and it follows that as the sword falls, so the leg will drop down and back in response, feeding more power and impetus into the attacking action.

female fantasy figures

Female fantasy heroes should look powerful and capable of great deeds of strength or daring, while retaining their feminine figure and disarming sexuality.

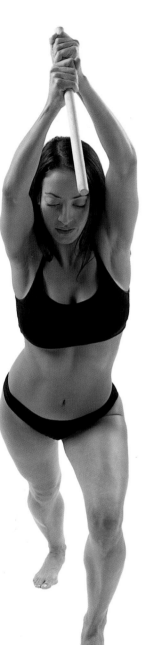

◀ Stabbing

The arms are raised and the knuckles are pronounced, displaying the strength of their grip on the sword or spear. The breasts are slightly flattened because the body is stretched and ready to strike, but because this is a standing strike, one leg stands forwards to balance the forward angle of the body, which in turn slightly angles the line of the hips.

▶ Sorceress

This is not an action pose, but it is still full of arrogance and confident threat. The leading leg is elegantly and coquettishly extended, unbalancing the line of the hips, as the arms extend forward in strong, sure lines.

▶ Warrior

This is a beautifully balanced and elegant pose. The extended leg is long and straight and is at right angles to the staff, giving the character added balance and strength. The right arm balances the body as it leans forwards, while the slope of the shoulders creates a diagonal almost parallel with the line of the leg. The staff is gripped with a strong hand, giving the pose a focal point.

1

2

3

▼ **Catwoman crouching**

The slim arms are angular and poised for action, while the shoulders are much closer to the ground than the behind. The head lifts up, creating the impression of movement, further suggested by the hair, which trails slightly.

▼ **Slayer**

The shoulders are thrust back, the breast pushes forwards, and the slim waist leads to the flare of the hips and a strong, balanced stance.

1. The face is lifted slightly and looks in the direction of the leading leg.
2. The leg is straight and powerful, planted firmly on the ground and defining the direction of the character's gaze.
3. The arm is straight and at right angles to the line of the eyes, adding stability and strength to the composition.
4. The staff is held ready, giving a sense of impending action.
5. The stomach muscles are relaxed but slightly twisted to the side.

▶ **Walker in the woods**

Both the right arm and right leg extend forwards to suggest stillness (movement is represented by simultaneous movement of opposing arms and legs), creating a diagonal hip line and strong leg shape. The left arm pulls backwards, causing the shoulders to pull together.

archetypal villain poses

As night follows day, so there must be a villain for every hero. The body language of a villain must communicate the propensity for evil and treacherous mischief.

▼ **Villain pointing**

The face is screwed up into a fierce snarl, while the body is angled forwards to give the impression of movement and direction, also suggested by the trailing heel being lifted from the ground.

▶ **Defeat**

The body is crumpled and cowed, with the back exposed to strikes from above. The head is low and faces the ground in hopeless defeat.

▶ **Villain creeping**

Keeping low, the torso is held parallel to the ground. The arms are tense and ready to lurch forwards and grasp the quarry.

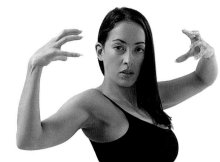

► Evil sorceress
The arms are raised in twin claws of menace and evil intent while the face is impassive and coolly confident.

► Villain making plans
With sloping shoulders and head angled slightly down, this pose is closed and still, full of calculating malice. The fists grasp one another, causing the muscles of the arms to bulge, and the feet are planted firmly on the ground.

4

1. The hands are ready to grab hold of a victim, and flex in anticipation.
2. The face is intent and focused, locking a steely, concentrated gaze upon his victim.
3. The muscles of the lower legs bulge to take the strain of the extreme horizontal angle of the torso.
4. The arms ripple with muscles flexed and ready for a sudden release of energy.

▼ Power hands
All the muscles of the torso are taut and well defined. The fingers are splayed to suggest that these are hands that can release powerful spells.

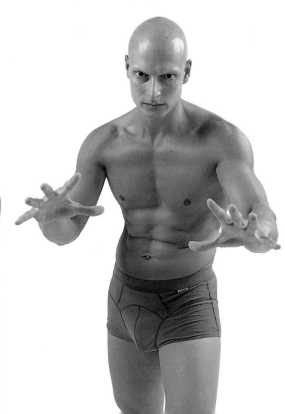

Understanding light

The source, colour and intensity of light in a scene has a huge atmospheric effect and can help to enhance and emphasise a character's anatomical details. A figure well lit by a natural light source, such as the sun, will always look less sinister than the same figure meagrely lit by an artificial source from an abstract angle. In a character partly concealed by shade, less is more and letting the viewer's imagination fill in the blanks can produce some powerful images.

types of lighting

You can add both visual and emotional impact to your work by inventive use of lighting, but first you must be aware of the conventions whereby lighting is used in orthodox art. The basic rules for lighting are these. Light usually comes from a single source. The position of that source in relation to the various elements of the picture determines, for example, how shadows fall and how facial features will be illuminated.

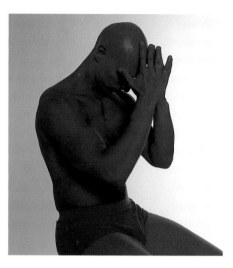

▲ **Coloured light** *Colour schemes, such as this alien blue, can give your fantasy scene a distinctly odd light, as if your subject were on another planet. Altering the colour in which you render your images is a fundamental way of establishing setting and emotion.*

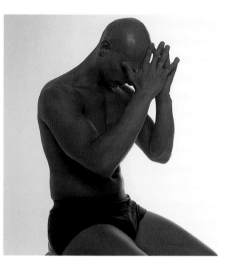

▲ **Silhouette** *By dramatically calling attention to a character's outline, silhouetting can be immensely exciting. It can effectively give your subject more "presence" than more orthodox means of portrayal.*

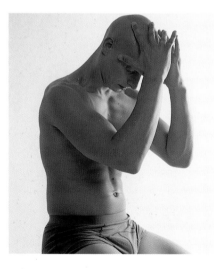

▲ **Abstract light** *For maximum contrast and dramatic punch, single source lighting from an abstract angle is the option to choose.*

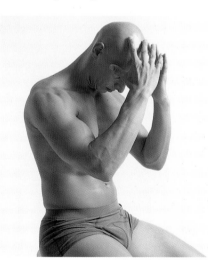

▲ **Natural light** *With soft, even shadows and natural looking highlights, natural light is not always the best choice for fantasy art as it gives a more diffuse effect than you would normally want.*

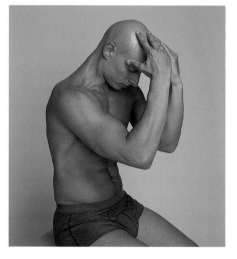

▲ **Low/dim light** *Light and shade are powerful tools in the artist's toolbox. In a dimly lit setting, this subject's skin colour seems to get warmer and his muscles are softly delineated to pleasing effect.*

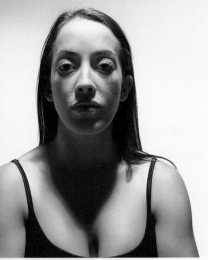

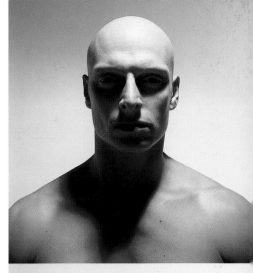

direction of light

The way lighting falls across a face can determine the way we perceive personality and expression. You are making your viewers alter their reading of mood and temperament.

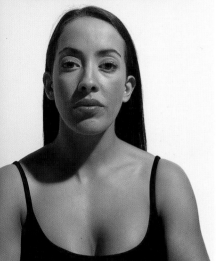

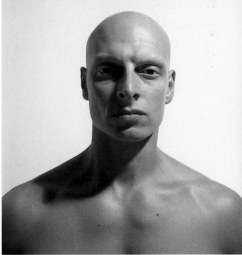

Woman top to bottom

From above
The lights have become colder and whiter, and the shadows have become blacker and more obscuring.

From front right
Definitely a more natural look. Reveals all the features in a balanced way.

From the right
Slightly sinister, emphasising her hooded eyes and cleavage.

Uplighting
The light creates odd shadows over and under her eyes, and her chin becomes bright white. The effect is jarring and quite bizarre.

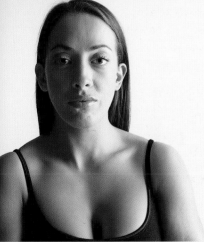

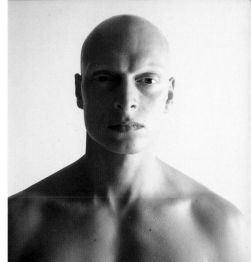

Man top to bottom

From above
The eyes are completely blacked out, and his bald head and heavy brow take on a potentially evil aspect.

From front right
The left side of his face is in shadow, but the effect is less stark than in the previous picture.

From right
The right side of his face and body receives fine attention to detail in the form of white highlights.

Uplighting
The brow and lower eyelids are emphasised and the muscles on his chest and arms are thrown into sharp relief, giving a sense of sinister strength.

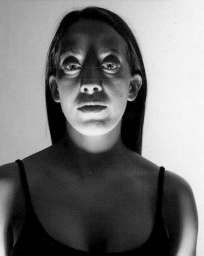

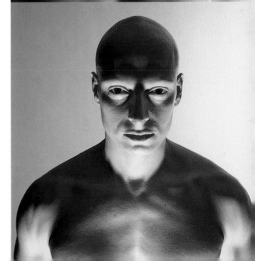

Practising drawing and sketching

To become a good fantasy artist, you must treat drawing in the same way as the acquisition of skills in any area – you must practise. It's impossible to express ideas unless you have the necessary technical ability. Develop your rendering of form and structure, light and shade by drawing from observation in your sketchbook.

This does not mean that you should not also sharpen your inventiveness by drawing and doodling the kinds of fantasy subjects that interest you from imagination – but you need to keep your art rooted in the real world. Anything you see in the everyday world around you is worth a sketch – street scenes, vehicles and people on trains or in cafés.

Always keep a sketchbook handy – preferably a cheap one, as you should get through it fairly quickly. There's no substitute for hard work, so if you want results fast, you're just going to have to keep practising. With practise, you will develop the link between eye and hand that is the key to fantasy drawing, and once the link has been forged, you will have begun to access your own creativity.

▼ **Freehand sketches** *These are the kinds of sketches you'd find in any life-drawing studio. Drawing a finished figure without first building it up in stages (see opposite page) takes a lot more hand-to-eye coordination and skill, but it's an ability that's useful for any fantasy artist.*

▲ **Simplified skeleton**
Start with a skull, rib cage, pelvis, hands and knees that are all represented by primitive oval shapes. Finish the rest of the skeleton with lines. Establish your figure with the right dimensions, shape and posture. Get familiar with this simple skeleton so you can reproduce it quickly and easily.

◀ **Adding muscles**
Continue to think in primitive shapes as you start to map out the muscles. This and the previous stage are the most important steps to master.

▲ **Fingers and toes**
Pencil in an outline for the figure. Add more muscular detail, some facial features and fingers and toes.

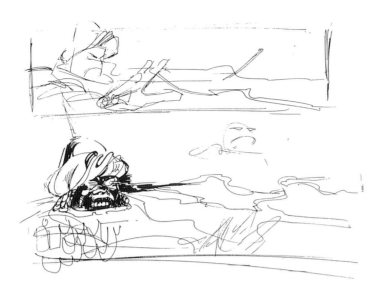

◀ **Quick sketches**
The samples here are by fantasy illustrator Ron Tiner, working in ballpoint pen to sketch out very quickly the main components of an image – the man, his outstretched arms and lightning coming from his eyes. Even though the sketches were done in moments, the dynamic of the finished image is contained in the shorthand sketches.

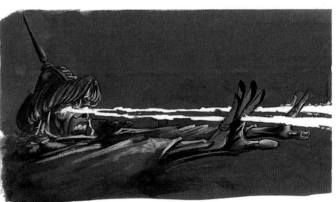

▲ **A character emerges**
Believe it or not, this is by far the easiest stage because you can concentrate on small sections at a time. Add clothing and accessories, and give the figure some more definite outlines by drawing over the light pencil lines already laid down. This stage is more about design than artistic ability, so think about the theme of the character and how this should be communicated by his expression, dress and adornments. This is not the time to be refining the shape of the character – if it looks wrong at this stage, go back to step one and try again.

Don't try to draw fully rendered illustrations every time. It's more effective just to doodle something easy, like your simplified skeleton, as this will loosen up your hand and improve your technique. If you feel the need to do something more finessed, work on just one feature at a time, such as a hand. Work more on the areas where your technique is weakest.

Don't be a perfectionist. If you want to get really good, you'll have to do hundreds, if not thousands, of practise drawings, so learn to let yourself run wild. It's difficult at first, but at this stage you should be drawing to improve your talent, not to compile a portfolio. Remember to keep your work space clear of stacks of old drawings. A clean workspace makes everything much easier.

Experiment with other styles and media. Working on a diverse range of styles will force you to try new techniques, and you may stumble onto ways of improving your own method.

capturing movement

By introducing movement to figures, you are effectively bringing them to life. Bodies are supple, flexible and rhythmical when they move, and an understanding of anatomy will help you to render convincing muscle movement, position and balance. Capturing the line of movement gives a clear sense of the flow, focus and intention of the action. Think about light and colour – a light-toned shadow with a soft outline suggests that the figure is not still enough to cast a firm, distinct shadow, while muted tones tend to slow movement down. Facial expressions become animated in movement, reflecting the power, pace and mood of the action.

in combat

In combat situations, poses and expressions are taken to extremes, but they must appear natural if your fight scene is to have its full impact.

1. Claws and teeth are additional weapons for the lizard, but displaying these subtly can give them a more intimidating presence and greater impact when the lizard uses them in combat.
2. The forward incline of the lizard's body makes it appear more imposing.
3. The moment of liftoff when the foot leaves the ground.
4. The degree to which a joint bends and the surrounding muscles flex during a movement give a good indication of the force behind it.

inner rhythms

The sinuous muscle form and the skeletal structure can twist, bend, extend, and fold to create a variety of shapes. Begin by visualizing the shape—such as a square or a rectangle—into which the figure fits and then identify the line of movement within the pose to understand the flow and rhythm of the figure's action.

◀ Stretching
The upward triangular shape created by the outstretched arms emphasises the swinging lift of the pose.

▶ Turning
In this pose drawn from the back, the weight is on the left leg, left hip raised. The figure has a forward movement.

5. A character's confidence can be seen by his or her posture and stance. This character's low, unimposing pose promotes his underdog status.

6. Notice the typical hero's physique and proportions – a broad chest, strong upper arm muscles and powerfully-built thighs.

7. Notice also how secondary movement in the hair and clothing can give an indication of the force behind the character's movements.

◀ The warrior *In combat, human characters are most frequently the heroes, so portraying them as the underdogs makes for a more interesting battle, and a greater emotional payoff when they win.*

1. The starting point – a simplified figure, reduced to its basic shapes.
2. Filling out the figure to portray convincing muscle movements, position and balance. This conveys the sense of movement and effectively brings the character to life.
3. The use of foreshortening gives a dynamic sense of the character's speed.
4. Balance your character with arm movements, which move in time with the legs but in opposite directions.

5. It is more difficult to use body language with a running character, so keep in mind that the facial expression is particularly important here.
6. For a greater impression of speed, lean your character further forwards, with the centre of mass in front of both feet.

in flight

Unlike a fight sequence (see previous page), running is a more regular and rhythmical movement. The action of running uses all of the leg muscles at once, and this is therefore the area to concentrate on when drawing your character. That said, try to look beyond the overall figure to factors such as balance and angles to convey the illusion of movement and speed. Lean characters are best suited to this activity, and will appear more graceful and elegant.

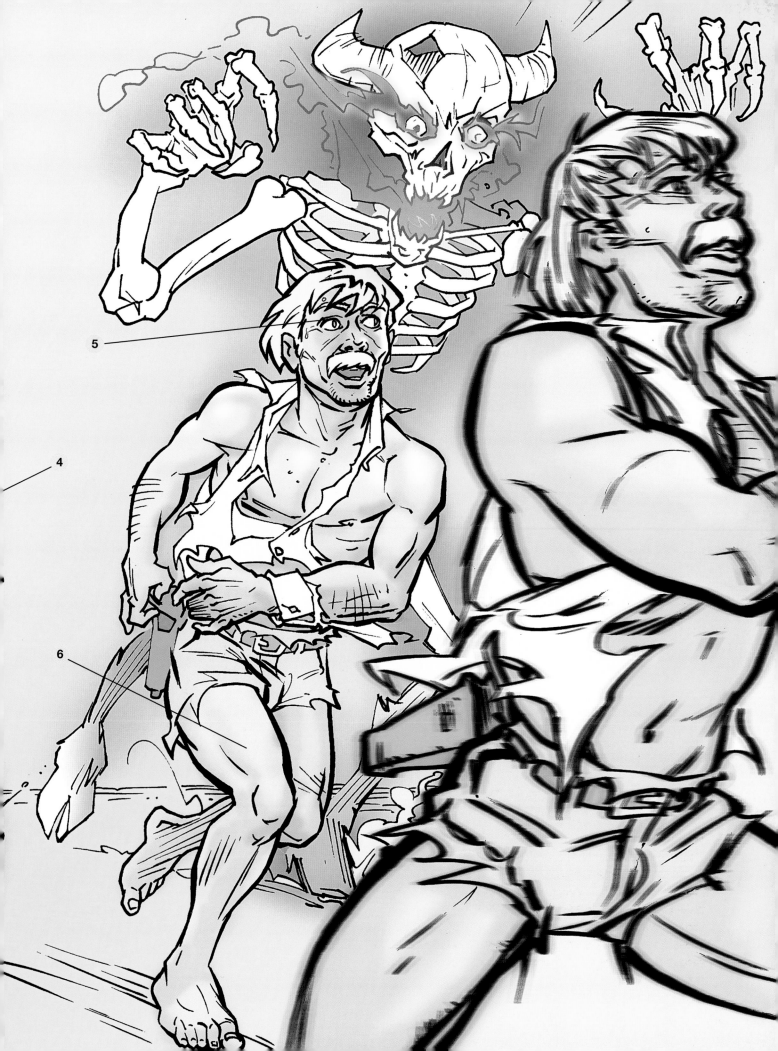

compositional study and finished painting

The primary function of this sketch by Keith Thompson is a study of composition and the gestures of the characters. The sketch captures many of the key elements that make up a finished piece of art – the sense of depth, the placing of focal points and how the eye is led through the picture. If you are working on a particularly high-contrast piece, you might want to include some quick tonal work in the sketch as well, as it will affect the composition.

1. All art should have a focal point. In this piece there is a hierarchy of descending foci. The point at which the weapons clash and the negative space around it framed by their faces makes a very dominant focus.

2. The artist has to take care not to allow the initial sketch to limit the final art. Improvements should usually be worked in as work proceeds. These additions should always hinge on and serve the original composition. In this example, note how the clouds frame and work with the characters in the final piece.

3. Secondary focal points lead the eye through the painting.

▶ **Avian duel** *Keith Thompson*
One of the key difficulties in drawing a winged duel is the placement of the wings. Most poses will have the wings covering up huge amounts of the scene, and artistic licence often has to be taken to give the characters sufficient exposure. Note that the wings are evolved hands, and each wing has all the joints of a normal arm.

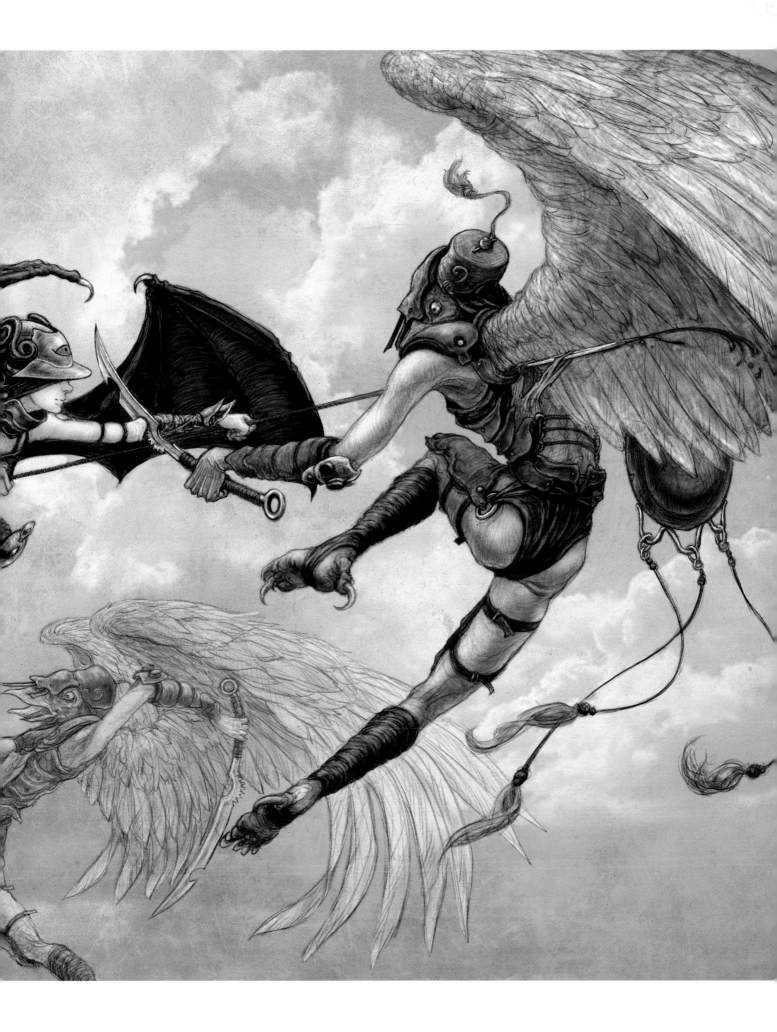

Getting inspiration

It's an old adage: the first step towards becoming interesting is to be interested. Artists of all kinds – illustrators, designers, writers, sculptors, musicians, playwrights – make the world their inspiration.

Learning to differentiate between what you like, what exists and what is good is an essential skill. You can never read enough fantasy-art books, but add to your reading list books on sculpture, architecture and cooking; even boxing, archaeology, travel and maths – it really doesn't matter, as long as they broaden your knowledge.

You can't make yourself get inspired. Like creativity, inspiration can't be forced; when it is, the results are bad. There are many ways, however, that you can encourage it. Inspiration can come from anywhere, in any shape or form. Obviously there are some places you are more likely to find inspiration, such as books, films, television, magazines and comics – the staple diet of any fantasy artist – but don't neglect the less obvious sources. Make a mental note of anything that catches your eye – from people to buildings, fashion to nature – and try to formulate it into an idea.

1. **Photographs** Snapshots of friends and family can be used to get proportions and poses right.
2. **Sports** Any forum where athletes show off their prowess. Take a sketchpad to your local running track. AUTHOR RECOMMENDATION: televised wrestling or ballet.
3. **Comic books** You need to study what other artists are doing, not to copy them but to assess the quality of your own ideas. AUTHOR RECOMMENDATION: *The Dark Knight Returns* by Frank Miller.
4. **Movies** See the best fantasy movies, especially if animated or with spectacular effects. AUTHOR RECOMMENDATION: *The Lord of the Rings* trilogy by J.R.R. Tolkein.
5. **Books** Get a feel for the written genre, from Sword and Sorcery to Science Fiction. Read the classics (start with *War and Peace*), history, popular science. AUTHOR RECOMMENDATION: Robert E. Howard, creator of Conan the Barbarian.

◄ **Where do you get your ideas?**
Fantasy artists are all asked this question. Almost all fantasy art draws on what has gone before. The best artists bring together many different aspects of their own experiences and mix them into new combinations and concepts.

keeping an idea bank

- A scrapbook or box file is a great place for storing anything that inspires you, from written articles to visual tear sheets.

- File your material using a system that works for you – filing ideas alphabetically may work for some people, but filing ideas thematically may work better for others.

- Keep adding to your idea bank and refer to it constantly. There may be something buried there that you had put aside for one project that might be perfect for another.

- If something grabs your attention, draw it, note it down, photograph it or file it away immediately. Not only will your drawing and research skills improve, but over time you will have built yourself a "catalogue of inspiration" that can be drawn upon at any time in your career and especially when you are short of ideas.

other sources

6. **Sculpture** Classical sculptures often have great physiques, and are worthy of study. Visit museums.
 AUTHOR RECOMMENDATION: anything by Rodin.

7. **The Internet** Easily the most streamlined and time-efficient resource. Personalise a library of bookmarks that give you inspiration.
 AUTHOR RECOMMENDATION: online galleries featuring work by the "modern masters," such as Frank Frazetta and Moebius.

8. **Art galleries** A great place to see how the Old Masters captured the human form.
 AUTHOR RECOMMENDATION: John William Waterhouse or Dante Gabriel Rosetti.

9. **Art materials** Play around in a new medium. Doodle. Use sketchbooks to experiment.

10. **Scrapbooks** Clip pages of inspiring physiques from body-building and fashion magazines.

11. **Figure reference manuals** A Japanese series called *Pose Files* features hundreds of photographs of men and women in different poses, taken at different angles, and lit in different ways.

12. **Recording devices** Being human means that we forget things in the hustle and bustle of our own daily lives. How many times have you woken up in the night with an idea and forgotten it in the morning? Or found yourself saying: "I wish I had a camera," or "I'm sure I saw something about that recently"? Every practicing illustrator, without exception, carries at all times some form of recording device. This can be a sketchbook, a camera, a tape recorder, a video camera—whatever is most relevant to the area of interest. These are updated on a near-daily basis. Illustrators also keep scrapbooks of material that interests them. Often they may not even know exactly why, or how, the material will come in useful.

▲ **Portraits**
For centuries, artists painted their portraits from mirror reflections. These days, polaroid cameras offer instant reference. Keep any photograph that inspires you and any that are distinctive. You never know when your grandmother's 90th birthday smile might come in handy!

Artist at work

Although the progress of this work is broken down into 19 stages, bear in mind that the faster you can do the main body of the work, the more energy your finished painting is likely to have. It's all too easy to get tied up in a particular detail and leave the rest of the picture to languish, so try to move about the surface of the painting so that the whole thing evolves at a steady rate.

tools and media

Experiment to find out which tools and materials you prefer and see how different media behave when used together.

- **CS10 art board** has a smooth surface to which paint is easy to apply.
- **black coloured pencil** for sketching, defining and shading – not water-soluble, so that it won't disappear when you paint over it.
- **acrylic paints** are cheaper and dry more quickly than oils (the ideal medium), so they are good for speedy work and for practising with. You can use them as they are to give thick, chunky textures, or you can dilute them (unlike oils) for smoother textures and washes.
- **watercolour brushes for washes** Apply as many washes as you like during painting to deepen the tone and soften gradations between tones – this heightens realism.
- **red and black ballpoint pens** for boosting outlines.
- **process white and small brush** for highlights and fine detail.
- **felt-tip pens** for details like the monster's markings.
- **toothbrush** spatter adds texture in a random way that looks completely organic. Dip the bristles in the paint and then run your thumbnail over them. You can then work into the spatter with a brush, picking out highlights.

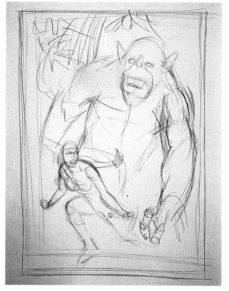

▲ **1. Composition**
Sketching out the basic idea in pencil, the artist will already have decided roughly what he wants his characters to look like, and how he wants to compose the scene. This primary stage maps out the illustration, gives you an idea of how the image will work as a whole, and provides a good framework upon which to build layers of detail in future stages.

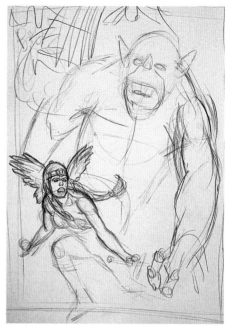

▲ **2. Anatomy and expression**
This stage adds finesse to the basic sketch. The lines become bolder and more detail is added, particularly to the winged female character.

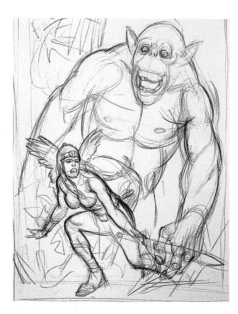

◀ **3. Line definition**
Here the characters have developed much more definition. Their shape is far clearer now, and the outlines are bolder and more circumscribed.
More steps on pages 60–63.

finished painting ▶

Glenn Fabry
This is a typical fantasy theme: Girl in Peril from Hideous Thing. It has a simple diagonal composition, with her line of action sloping to the left and his to the right. Her colour scheme is warm and his mostly cold. Each of them has a strong white highlight, almost in outline, to draw them out from the background.

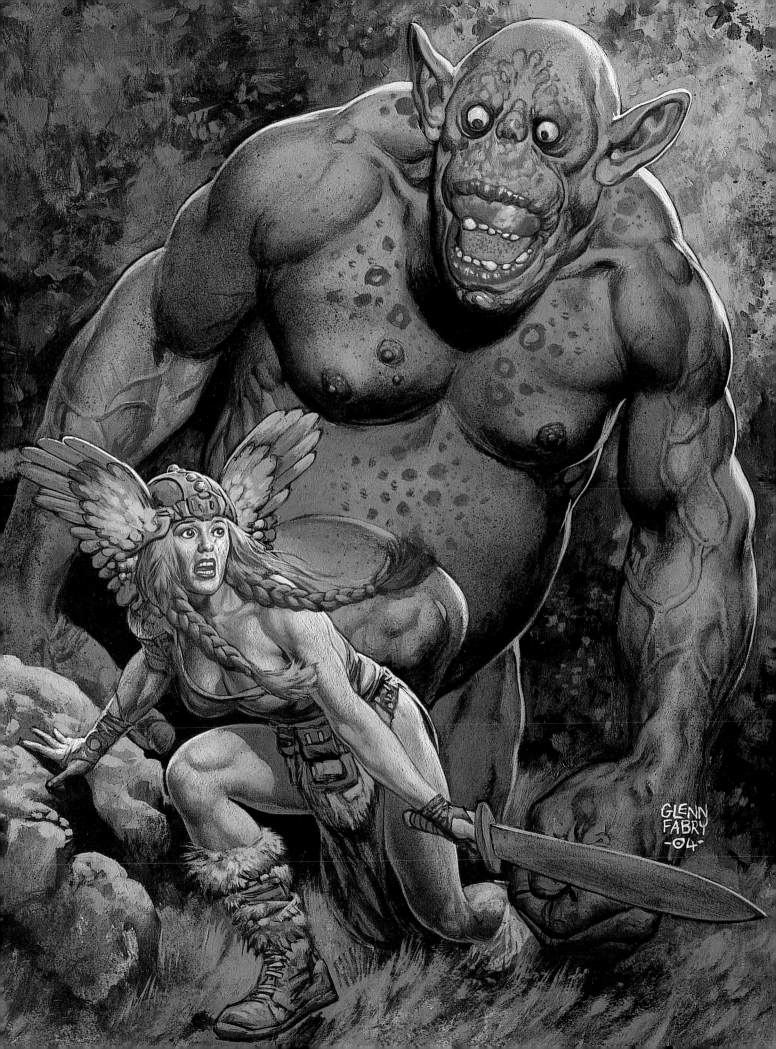

▶ **4. Shading**

Now the smaller details are given definition. Notice particularly how the ears have really begun to take shape. Also, the artist has begun to add some simple pencil shading to give a better idea of the placement of the muscles.

colour palette

This painting uses a balance of cool colours (blues and greens) and warm colours (reds and oranges) to give contrast between the monster and the girl.

Acrylics
- alizarin crimson
- black
- burnt sienna
- burnt umber
- cadmium orange
- cadmium red
- cadmium yellow
- cobalt blue
- emerald green
- grey
- light magenta
- Naples yellow
- pthalo blue
- violet
- white

Coloured pencils
- black
- white
- pink
- grey
- brown

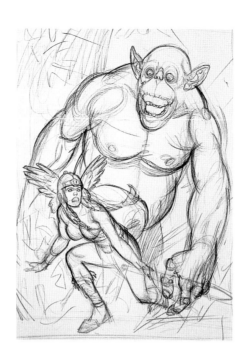

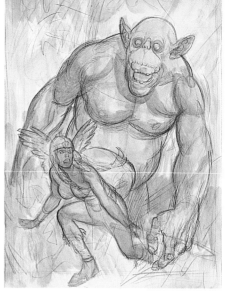

▲ **5. Adding colour**

Now we can begin to add colour. The final rendering of an illustration is a long, detailed process which comprises several stages of building up detail in layers. This first stage adds shading in the appropriate places, giving the character more volume and shape. Notice how the artist shades quite lightly, and with a colour other than black – if you're building up colour in layers, it's very easy to darken the colours in the final stages, whereas lightening them can be extremely difficult.

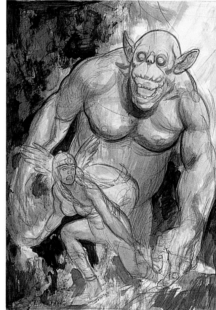

▲ **6. Background**

The artist adds some atmospheric detail to the background. He's chosen colours that are unusually dark for such an early stage of the rendering, but this is fine because the final image is very dimly lit. If you do make a mistake and accidentally go too dark, the best way to remedy the situation is to let the paint dry, and then repaint over the top.

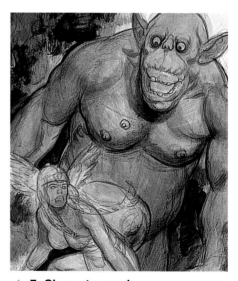

▲ **7. Character work**

The monster's expression is defined with black colouring pencil, and muscle definition is established once again. Expressions get bolder and highlighted with touches of white. Our heroine gets a white dress and wings.

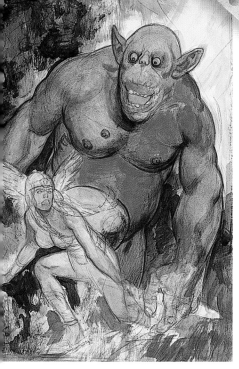

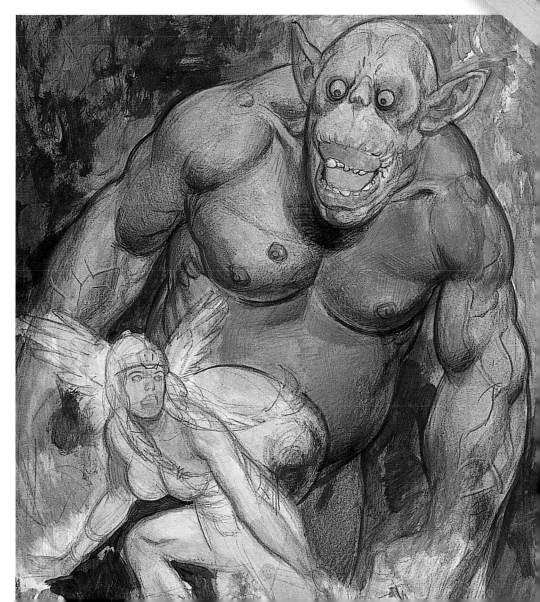

▶ **Palette**
Sometimes you can achieve such interesting effects on the palette that you might want to recreate them in the painting itself, or keep them aside for little abstract works.

▲ 8. Concentrated colour

The artist adds blue tones to the monster, and redefines the pencil lines. Depending on how many layers you use to build up your colour, it may be necessary to do this several times.

▼ 10. Colour detailing and highlights

Here the artist adds some small details that give the monster a more organic feel. The veins on the arms promote a feeling of believability around the character.

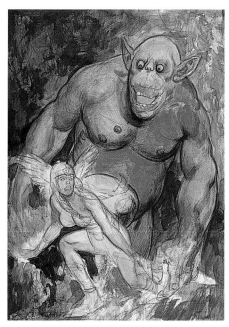

▲ 9. Tones

More colour detail is added to the mouth, and the artist starts to build up tones in the background. Rough brush strokes are an easy way to quickly create areas of colour that can act as a reference for building good colour schemes across the whole image. This will help to produce an interesting texture when you add more detail later.

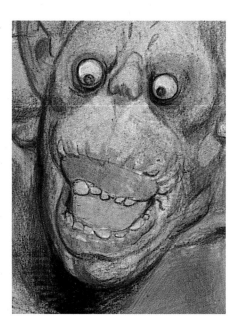

▲ **11. Whites and brights: monster**
The artist gives the monster yellow teeth and bright white eyeballs.

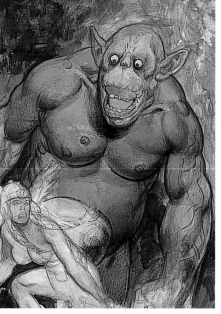

▲ **12. More colour work**
More colour is added to the monster in this step. When you are mixing colours on your pallette, always add dark colours to light, and not the other way round. This will save you not only lots of time and effort but also lots of paint.

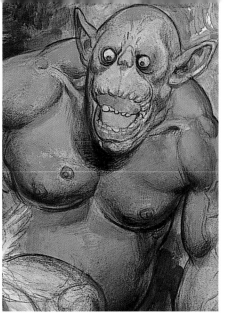

▲ **13. Colour detailing**
Colouring is about texture as well as shading, but you don't have to worry about both at once. Here the artist has done some textural work on the monster's body, leaving it ready to be shaded at a later stage.

◄ **14. Face and body detail**
The artist now turns his focus to the female character. Basic colour is added to her face, and her entire body receives more penciled detail.

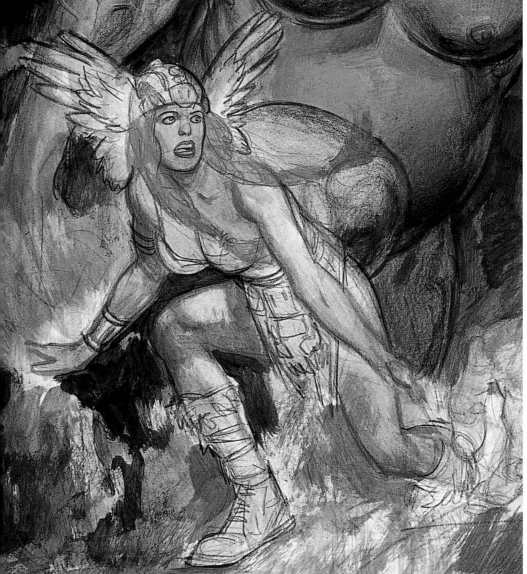

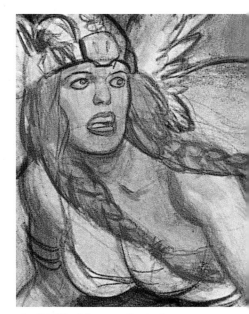

▲ **15. Working on the hair**
The outline of the girl's hair was becoming slightly vague under the colour, so this is re-established. Also, the first signs of colour appear on the wings of her hat.

▲ 16. Texture work

More texture work is added to the ground here. At this stage, keep your textures bold and don't worry about being too liberal with your freehand skills. You can always correct mistakes later, and organic textures are usually pretty messy anyway.

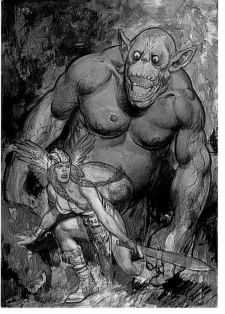

▲ 17. Good foundations

All the basic colour is now in place, and the areas where pencil detail was unclear have been reaffirmed. We can see at this stage that the colour scheme has worked well and the foundations for some good texturing are in place.

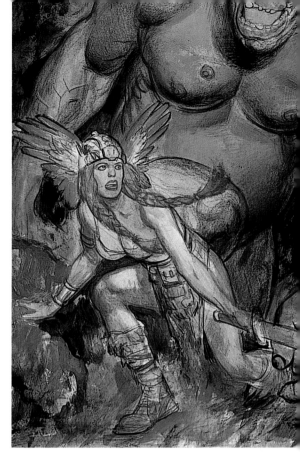

▲ 18. Adding crimson detail

Using crimson, the artist adds some details to the girl, her clothing and some of the background.

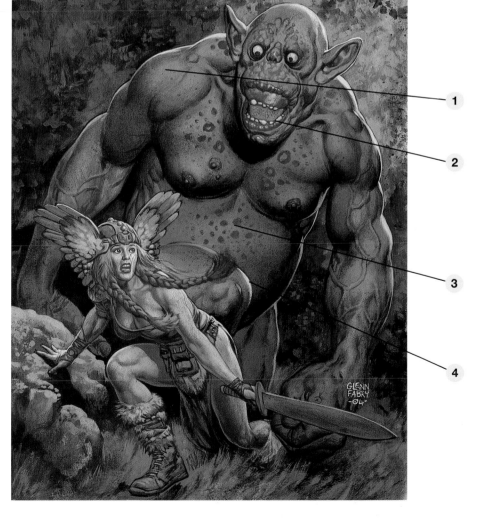

◀ 19. Finishing touches

Once you are happy with the way your colours are working together, all that's left is to add the small details that make an image appear more realistic. This is the most intricate part, so don't try to rush it. The artist has added a lot of detail to his textures to make them appear more organic, and has done a lot of finishing work on his shading to make the image more realistic and atmospheric.

1. Toothbrush spatter adds tone and texture. You could also try dabbing thick paint on with a sponge and letting it dry before working into it.

2. Boost outlines with a red or black ballpoint pen. The waterproof ink is ideal if you've used washes.

3. The monster's markings were done last, in felt-tip pen.

4. Highlights are best done in the very last stages. Be as bold as you can, but choose carefully where you place them.

Cast of characters

Here is a gallery of characters to inspire your creativity, demonstrating and applying the techniques taught in the previous section. They give just a taste of the boundless possibilities open to you as a fantasy artist. Use this gallery as a spark to fire your imagination to create your own unique characters.

Sven the barbarian

Sven is our not very lovable Viking hero, or antihero, with the typical mesomorphic body of the hero in fantasy art. Sven is a muscular, athletic character with an aggressive and outgoing personality. He is very fit, like a body builder, with well defined musculature and hardly any fat. Sven has an impressive stature with slim hips and waist, broad shoulders, big arms and legs and a thick neck.

key characteristics

1. Surly, belligerent, aggressive expression, known in the industry as "the Arnie".
2. Helmet, loincloth and bracelets in place.
3. Chest is big and broad; main features are the pectorals (pecs).
4. Abdominals (abs) well-defined, the popular "six-pack" of the bodybuilding tradition.

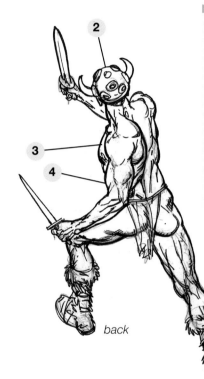

back

from all angles

Because of the range of mobility of the trapezius it is important to use reference material when drawing such a well-built character. When wielding a sword, it will be necessary to pay attention to the arms – the flexors along the front of the arm, supinators and extensors on the back of the forearm.

side right

side left

front

◀ **portfolio picture**
Liam Sharp
Barbarians are in their element when shown in battle scenes. The background of carnage and destruction here only adds to the overall picture.

action poses

For poses such as these it is helpful to begin by establishing a line of action, which is the direction your figure should move towards. It can be direct or twisted, but if you can visualise it from the outset it will give your drawings more energy and life. The line of action mainly runs through the legs and spine, but you can adapt it depending on the pose you want to portray.

Punching
Sven throws a punch, and the body moves away from it, giving a nice stretch.

Twisting
Socked in the jaw, Sven twists back from the punch, making an almost balletic movement. Never think that a muscle-bound character can't be graceful!

facial expressions

Here is Sven's head from a variety of angles, all showing his habitual look of contempt. His eyebrows are knotted, eyes narrowed, mouth turned down.

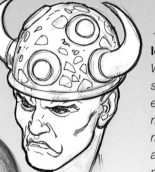

◀ **Three-quarters looking down**
With the head looking slightly down, the expression can become more extreme, with the mouth turned down and the eyebrows more arched.

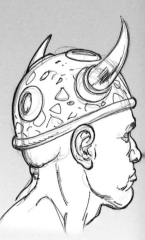

▲ **From the side and to the back** *This angle shows the powerful neck muscles and jutting jaw.*

Charging

Retaliating with a shoulder charge, the action line runs from his back foot through his shoulder.

Leaning forwards

The line of action runs through the right leg to the head.

▶ **Looking up**

A three-quarter view, this time looking up, with the nose partially obscuring the eye on the right.

▶ **From below**

From this angle even the most knitted of eyebrows could suggest concern rather than aggression, so you will need to use artistic licence to make his expression more severe.

 Looking down

The eyelids follow the ball-and-socket forms of the eyes, and the curve of the helmet defines that of the forehead.

Muscles *Sven's all-over great muscle tone is one of his most important trademarks. This is very much the typical "hero" physique.*

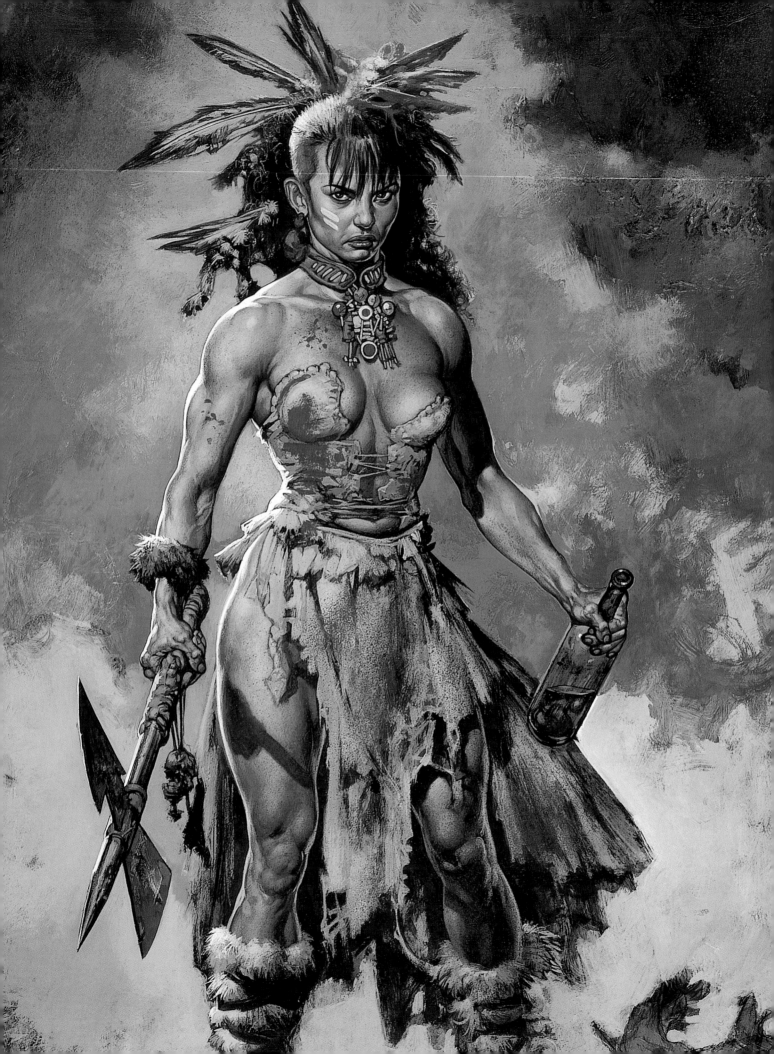

Sonia the adventurer

Sonia's most immediately recognisable feature is her muscular body – she's so hefty, in fact, that it can sometimes be tricky to allow her to retain her femininity. It's important to remember the standard proportions of the female fantasy figure's body: about eight and three-quarter heads tall, with wide hips, narrow shoulders, and petite hands and feet.

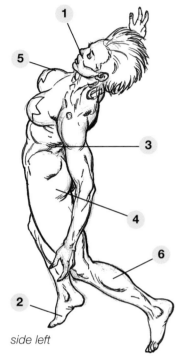

side left

key characteristics

1. Masculine facial features (bold) and head shape (rounded).
2. Undersized hands and feet.
3. Waist barely narrower than hips – unusual for a female character.
4. Extremely well-defined muscles.
5. Focus drawn away from feminine features.
6. Body shape in general dictated much more by muscle than by bone.

from all angles

Sonia's masculine nature is reflected in her stance. She is usually positioned exactly as one would arrange a male figure, highlighting none of her feminine attributes. Only the female head, breasts and clothing tell us this is actually a feminine form.

side right

front

back

◀ **portfolio picture**
Glenn Fabry
The addition of decorative feathers, primitive costume jewellery and face paint all contribute to the character's distinctive image.

facial expressions

Much of Sonia's personality is revealed by her hair and make-up – loud and wild! But for a really believable expression, every part of the face and body should be saying the same thing, including the position of the head and the tension of neck and shoulder muscles.

◄ **Three-quarters looking down** *This shows how hair and accessories can really speak volumes about a character.*

▲ **From the side** *Notice how the angle of the head can affect the overall perception of an expression.*

► **Looking up** *This view emphasises the thick, well-defined muscles of the neck, indicated by a strong outline and minimal shading.*

Amazon *Sonia's masculine traits are unusual among female fantasy figures, and provide a challenge to the artist who must show both her masculine and feminine side.*

▲ **Three-quarters from the front** *The relaxed facial expression and proud position of the head give the impression of a self-assured, perhaps slightly smug temperament.*

action poses

None of Sonia's muscle groups stands out as larger than others, but because she is well-toned enough for most of them to be visible, you need to remember the whereabouts of all of them for each drawing!

Kneeling

The triceps are the main focus here – notice how each set is influenced by the position of the hand.

Skipping

Wow! Just look at those huge quads! If you're unsure which muscles will be flexing during a particular movement, perform it yourself and feel the way the muscles work. But don't try anything too dangerous!

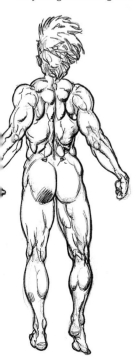

Stretching

When concentrating on the back, observe how numerous groups are visible in the lower back alone, and that the thick calves also have clearly defined muscles.

Stumbling

Exaggerating the incline of the moving body can give the drawing more impact.

Stance *Sonia's masculine stance can also be provocative.*

Myrddin the wizard

Wizards aren't always scrawny and gaunt, and our wizard Myrddin proves it. He subverts our expectations while adapting some classic characteristics. He is accustomed to long, tough journeys and many years hunched over books. He has great stamina, little body fat, and a powerful muscularity often concealed beneath a cloak. This wizard's physical strength cannot be judged by the length of his beard or the lines on his face.

facial expressions

Deep wrinkles and luxuriant facial hair characterise the wizard's features. Furrows are deeply etched on the forehead and around the eyes. His expressions are sometimes stern, sometimes benign.

◀ **From the front** *This intense head-on portrait is given additional drama by the double light source. The slight arch of the eyebrows and opening mouth suggest a questioning aspect.*

▶ **From the left** *The wizard in a more thoughtful mood. The knitted brow and narrowed eyes suggest introspective musing. Profiles also highlight the large hooked nose.*

▼ **Looking down** *Here he looks up at us through heavy eyebrows, with his expression perhaps suggesting an unwelcome interruption or a prelude to a warning.*

◀ **From the right** *This profile shows the wizard in a lighter mood. Almost closed eyes, clear laughter wrinkles, and bunched-up cheeks give a subtle impression of good humour.*

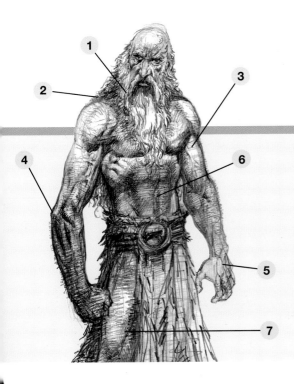

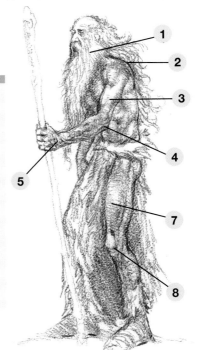

side left

key characteristics

1. Long white beard, hooked nose, craggy overhanging brow and bright, intelligent eyes.
2. Powerful, hunched-up deltoids.
3. Strong, sinewy upper arms.
4. Swollen elbows.
5. Powerful forearms and hands.
6. Lean, wiry abdominals (abs).
7. Long, slender thighs.
8. Swollen knees.

from all angles

Looking at the whole body gives us a clear picture of the wizard's physique and posture. His head is thrust slightly forwards in an inquisitive manner and his shoulders are hunched. Yet the wizard is sustained by inner forces, and his strength, although not the product of a warrior's training, is very evident in his musculature. However, his swollen joints and haggard features clearly show that he cannot completely escape the ravages of time.

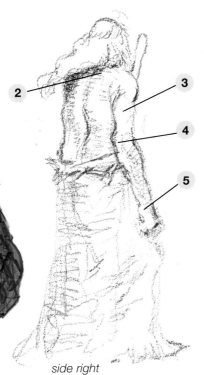

side right

Concealed strength

The wizard's aged appearance belies his power and agility.

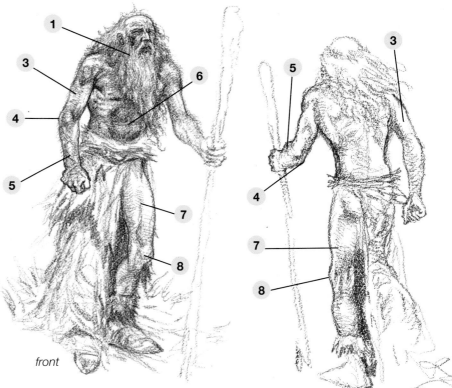

front

back

action poses

The vertical line in each of these sketches is the line of action which indicates the direction in which your figure should move, and gives the piece momentum and energy. The movement is normally through the legs and spine, but you can adapt it depending on your needs.

Standing
The wizard's powerful musculature, as displayed from the back.

Commanding
The wizard's authority and power is conveyed through his posture and stance.

Triumphant
Here we see the wizard in a classical, heroic mode. His right latissimus dorsi (lat) muscle is visible cutting across his torso, lending his figure tension.

Imposing
In this preliminary sketch we can see the wizard's muscular chest and abdominal cavity. His arms are slender but powerful, as are his legs.

portfolio picture ▶
Martin McKenna
Notice how the setting contributes a great deal to the figure's sense of character. This same character portrayed over a backdrop of a 1970's roller disco, for example, would give a distinctly less magical overall impression.

Charybdis the alien female

Sultry, shamanistic and thoroughly strange, Charybdis embodies what every artist looks for in an alien female, though physically she is based on the female heroine figure. Keep the image simple, paying attention to the basic form and the way the joints move. No figure is entirely believable unless the foundation is in place first.

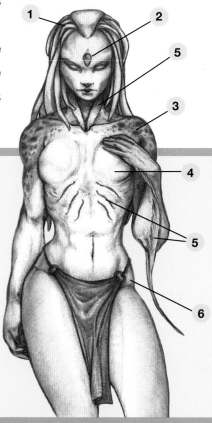

key characteristics

1. Alien "hair" – thick strands of flesh.

2. Forehead marking – individual features such as these help to create a complete picture of the character.

3. Skin markings give the skin a tougher, more nautical feel.

4. Skin does not sag at all – this is particularly visible on the breasts.

5. Gills on the torso and neck, and fins on the forearms.

6. Wide hips and narrow shoulders mimic the generic female heroine figure.

facial expressions

Charybdis's muscles appear to be made from a more turgid material than we are accustomed to. This suggests a greater degree of strength but also a more meagre level of expression. Only subtle changes in expression hint at what lies beneath the stony façade.

◀ **Three-quarters from above**
Coarse, but the slightly furrowed brow creates a suggestion of thoughtfulness.

▶ **From the side, looking up**
Tiny details, like the way in which the edges of the mouth are slightly turned down, can give a distinctly angrier look.

1
2
3
4
5
6

front

1
3
4
5
6

back

1
2
3
4
5
6

side left

3
1
2
4
6
5

from above

from all angles

These character sketches from different positions show how dramatically the shape of muscles can change depending on the character's pose and the artist's viewpoint.

◄ **From the side and to the back** *Notice the gill on the upper part of the neck. This echoes the gill-like openings on the torso and makes the attribute more believable.*

Marine alien *The immediately recognisable female physique is given a strong sense of strangeness by the oddly textured skin and the fleshy, snakelike strands of "hair". The glowing eyes are a dramatic touch, rounding off the image nicely.*

► **From above** *Observe how firmly the "hair" is stylised – there's no room for flimsy half measures in fantasy art, so be bold.*

action poses

Charybdis's marine references are developed here with the addition of the harpoon. It's always advisable to retain as much continuity as possible with a character's attributes. Otherwise, it's likely that your character will become unconvincing.

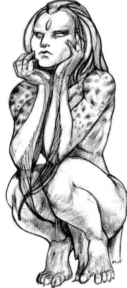

Perching
Notice how the embellished positioning of the fins compensates for the reduced secondary movement in the hair.

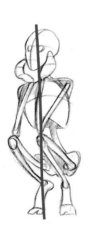

Crouching
The character's defiance and power are conveyed in her eyes and the positioning of her hands.

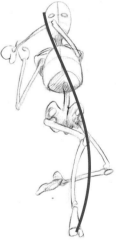

Lobbing
The positioning of the legs and arms here suggest a body tensed for action.

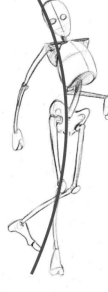

Standing
The extreme foreshortening of the left arm makes the posture look more comfortable and believable.

portfolio picture ▶
Joe Calkins
The character's alien nature is reflected not only in her strange colouring but also in the otherworldly nature of her surroundings.

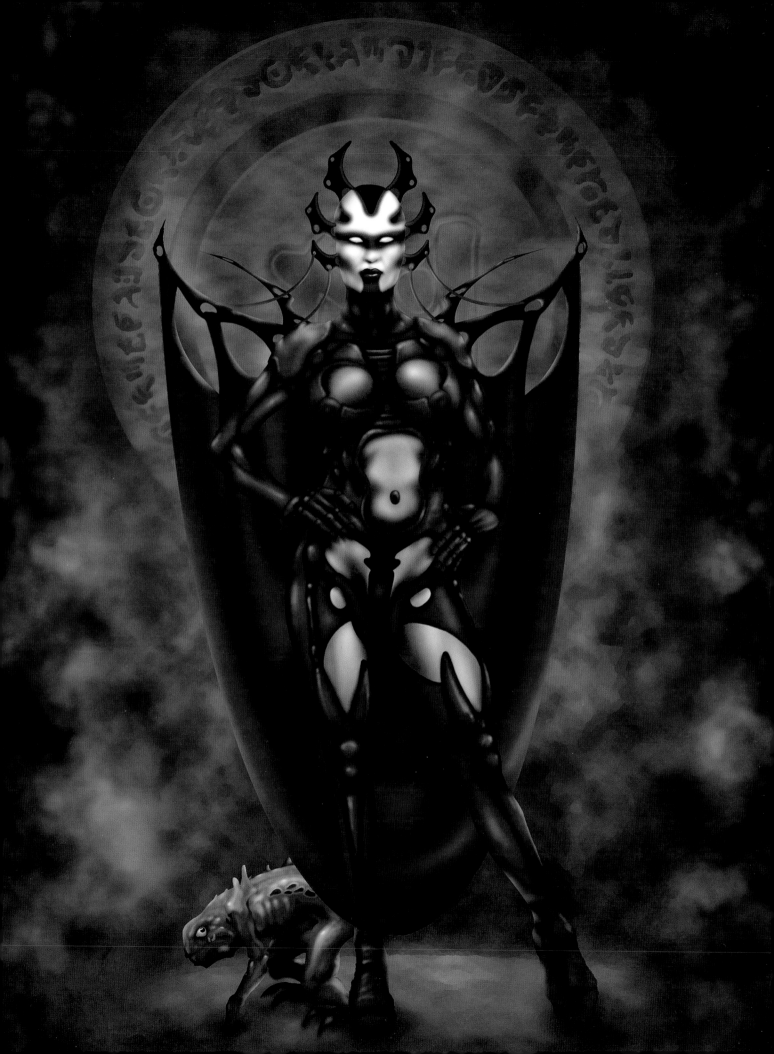

Mk2 the robotic female

Mk2 is the second model in a series of combat robots intended for MOUT (Mobile Operations in Urban Terrain) deployment. Quick and agile, the Mk2s utilise speed and surprise in guerilla warfare and are effective against both soft and hard targets.

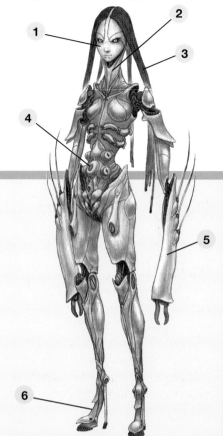

key characteristics

1. Visage is a plastic mask, the eyes swivel and the irises dilate or contract.
2. Long neck can swivel 360°, allowing more freedom of vision.
3. Hair acts as a heat sink and can steam during high activity.
4. Antennae carry myriad sensors.
5. Long, insectlike limbs tipped with alloy pincers.
6. Gyroscopic balance allows minimal ground contact.

robotic features

The Mk2 is graceful, but also very direct in its actions. Based on speed, this robot tends to spring and lunge in a linear fashion. Although the anatomy is long and thin, all the limbs are curved like those of a human.

◄ **From the back** *Panels on the head flip open and rotate. This exposes internal sensors and systems and can allow an even larger and more diverse field of vision.*

► **From the side** *The Mk2's insectoid features are clear in its swivelling eyes and long neck.*

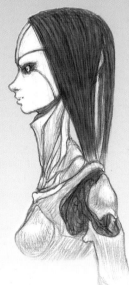

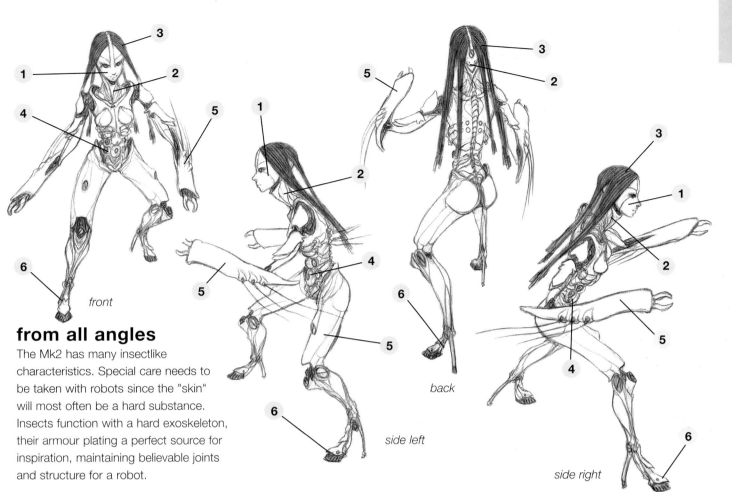

from all angles

The Mk2 has many insectlike characteristics. Special care needs to be taken with robots since the "skin" will most often be a hard substance. Insects function with a hard exoskeleton, their armour plating a perfect source for inspiration, maintaining believable joints and structure for a robot.

front

side left

back

side right

▶ **Hair** *The four sections of hair can move relatively freely, but the Mk2 tends to keep it brushed back and out of the way.*

◀ **Arm** *The arm is long, insectoid and covered in an extra thick bulletproof sheath.*

Heavy-metal woman
The Mk2's appearance is an unsettling mix of insectoid, humanoid and machine.

action poses

The Mk2's female appearance delays return fire from human combatants. Her body design maximises her battle potential, both offensively and defensively.

Shooting
The Mk2 has swivelled her arms back to deploy her integral flechette guns. The arms also tuck her hair back from the ejecting shell casings.

Defending
With one leg back to anchor herself and absorb the shock, the Mk2 crosses her arms to defend against a barrage of fire.

Lunging
Lunging directly at an opponent, the Mk2 stays low to the ground.

Springing
Leaping, the Mk2's arms can swivel at an angle that would be impossible for a human.

portfolio picture ▶
Keith Thompson
In real life, design is often hindered by functionality. Not so with the robotic female. In this artwork, its cool curves and awesome accessories defy logic but look amazing.

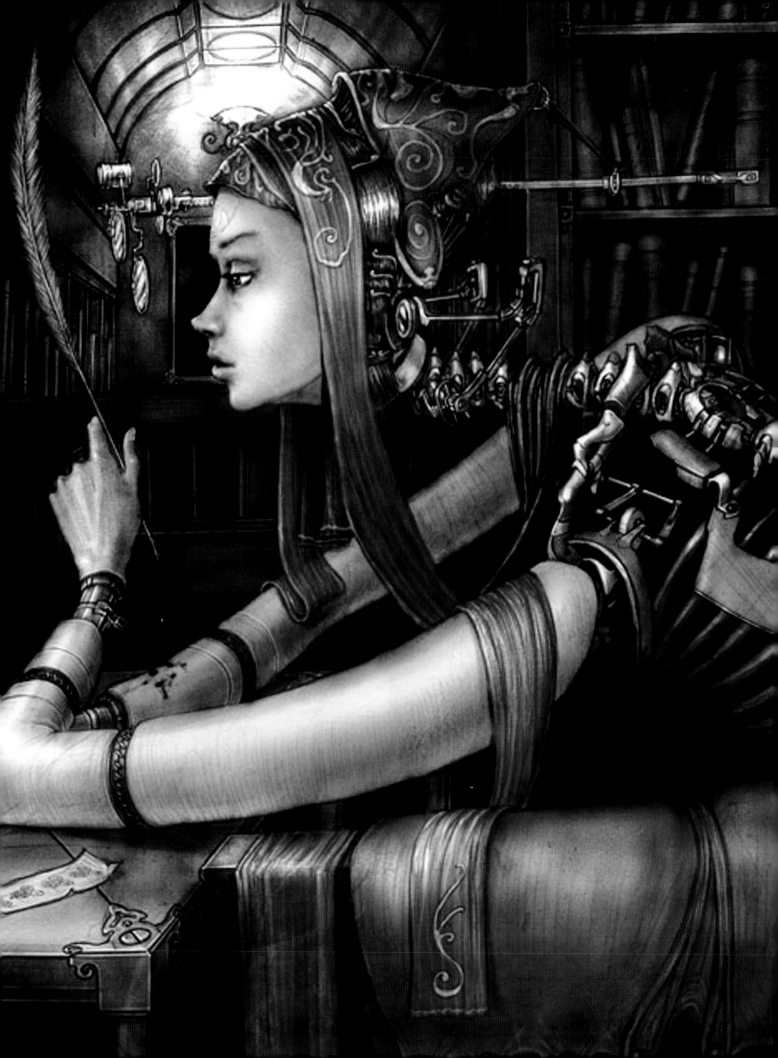

Circea the enchantress

Betrayed by men, Circea uses her powers of enchantment solely for revenge. She tempts heroes from their true paths and casts spells to change them into animals. This lovely female appears quite innocent to those she ensnares, but her innocence is all an illusion. With charms few can resist, the beautiful Circea tempts men into her lair with sensuous dances and then transforms them into swine.

key characteristics

1. Dark hair and cape.
2. Exaggerated curves.
3. Stylised hands with long, thin fingers.
4. Rib cage smaller than average.
5. Hips placed higher than normal.
6. Extremely slender ankles and wrists.

hand gestures

The enchantress's hands are especially important because she uses them to transfix her quarry and, inevitably, to unleash her dark magic when she gets it under her spell. Start with your own hands and stylise them later: this way you will be able to map out an image with good proportions and perspective and then add special characteristics such as these long, slender fingers.

◄ **From the side, looking down** *The somewhat contorted hand stresses the dark side of this lovely character's nature.*

◄ **Looking up three-quarters** *The whole hand is exaggeratedly slender and willowy, and the effect is enhanced by graceful movement and positioning.*

from all angles

Notice here how the enchantress's body, which is essentially round and smooth, contrasts with the sharpness of her features, her elongated hands and feet and the relatively petite size of her head. The enchantress is scantily clad, and her clothes are designed to leave little to the imagination (all the better to lure her male prey!).

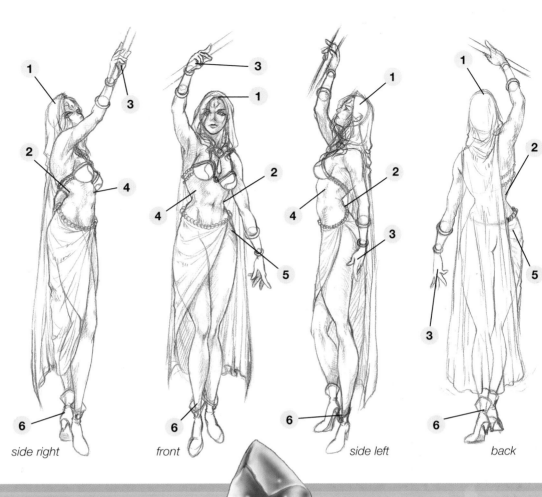

side right

front

side left

back

◄ **From above**
Every part of a character should say, or reaffirm, something about that character, so it's important to maintain the sleek feminine look in every feature.

▲ **Side left** *A general rule in fantasy art is that the more evil the character, the more distorted and twisted her postures will be. Small details such as the position of fingers and movement of clothes and hair can make a huge difference.*

► **From below**
Additional small details such as pointed fingernails and the bracelet that shows off the thin wrist are a good way to emphasise a character trait.

Come hither *The mixture of beauty and sexual allure makes the enchantress a bewitching character.*

action poses

The artist used Art Nouveau prints together with images of dancers as references for her work. Although Circea's dance poses are modelled on real people, a fantasy element has been introduced by elongating her limbs and exaggerating the curves of her body.

Leaping
Notice how the arm appears to shorten as she leans towards you. This is a perspective effect known as foreshortening, and it can be exaggerated to create a sense of space and movement.

Kneeling
You can almost imagine the enraptured male's gaze taking in her every move as she tricks him with her heavenly dances and leads him to his doom.

Reaching up
This image highlights the contrast between the rounded figure and the sharp angularity of the features, hands and feet.

Standing
The exaggerated proportions are highlighted, and the artist has also tilted the hips slightly, which can be an excellent way to make your character look more alluring.

portfolio picture ▶
Michael Cunningham
In this interpretation, the enchantress's pale skin, sharp features, taloned hands and dark outfit lend her a much more sinister air.

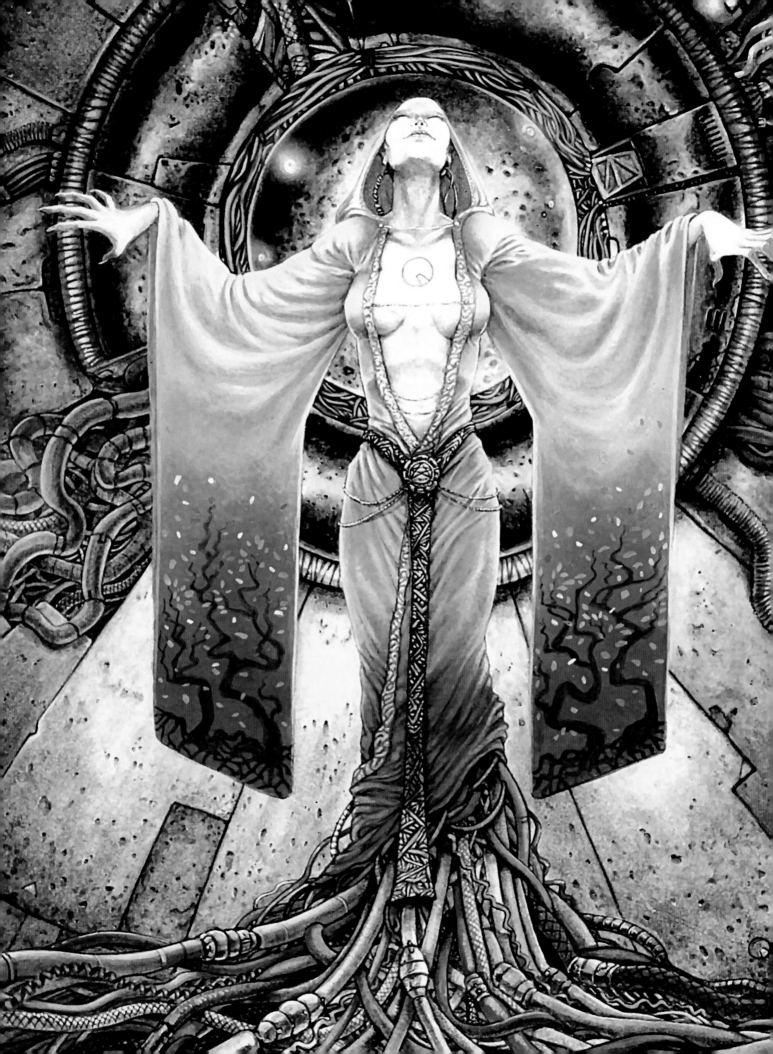

Brutus the hulk

Brutus has an immensely broad back and enormous arms – twisted forwards into an apelike stance to better display their mass and exaggerate his vast trapezius muscles. His comparatively small head appears half submerged in his torso, and he wears very little clothing. Such hulks generally stand around six and a half to seven feet tall.

facial expressions

A chilling evocation of a pugnacious hard nut. Everything about Brutus's facial expressions is guaranteed to instil fear into his enemies.

◄ **From the side** *In profile we can see his shattered nose and jutting jaw, as well as the cavernous overhang of his brow. Heavy shadows here lend brooding intensity to the character.*

◄ **From above** *This forward-facing head shot from slightly above is standard fare in barbarian fantasy paintings – "Time to die..."*

► **From above, front left** *This semi-profile from slightly above the figure gives us a good look at his brutishly thick, almost square skull.*

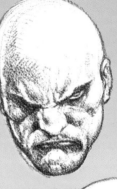

"Don't mess with me!" *This pose suggests barely controlled aggression.*

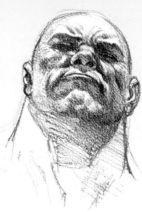

◄ **From below** *This view gives an overwhelming sense of Brutus's height as well as his bulk. The down-turned mouth is smugly contemptuous, and the threatening knitted brow is all but pointless – a picture of self-assured might.*

side front left

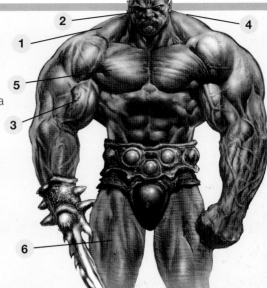

key characteristics

1. The trapezius muscles (traps) extend across the shoulders from the base of the skull to halfway down the back.
2. A permanent frown. The steely glare of a killer burns in his beady eyes. A wide broken nose, down-turned mouth and clenched jaw.
3. Huge triceps for truly Herculean arms.
4. Latissimus dorsi (lats) of spectacular proportions.
5. Dense, striated pectorals (pecs).
6. Thick quadriceps (quads).
7. Massive calves.

from all angles

Seeing the hulk from all angles reveals just how deep-chested this character is. His mass is concentrated in three main areas: lats, which give him that great wide back and classic "V" shape; triceps, which constitute the largest muscles in the arms; and traps, which bunch up around his neck and shoulders, giving him that hunched-over bulldog look.

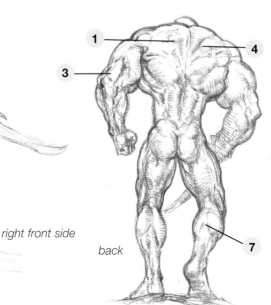

back left

right front side

back

action poses

Whether in repose or in action, the hulk's extreme physique is on display, every muscle exaggerated and given definition.

Lurching

In hulking characters, the back is especially important. This drawing shows the lats clearly, and the way the muscles in the back bunch against each other. You can also see how the deltoids (shoulder muscles) roll back when the arms are lifted.

Reclining

Unlike Adam, the hulk must create himself. Such mass has to be rigorously maintained, which makes many hulking characters exceedingly vain. In this classical pose we can still see the incredible breadth of the lats and the dramatic narrowing at the waist. Even when relaxed, the hulk is impressive.

Springing into action *This pose shows how even so vast a bulk can be given grace, speed and agility if handled right.*

portfolio picture ▶

Michael Cunningham

Notice how thick the hulk's arms are, and how the main muscle groups (biceps and triceps) are complemented and given a better overall shape by the numerous bulges that surround them.

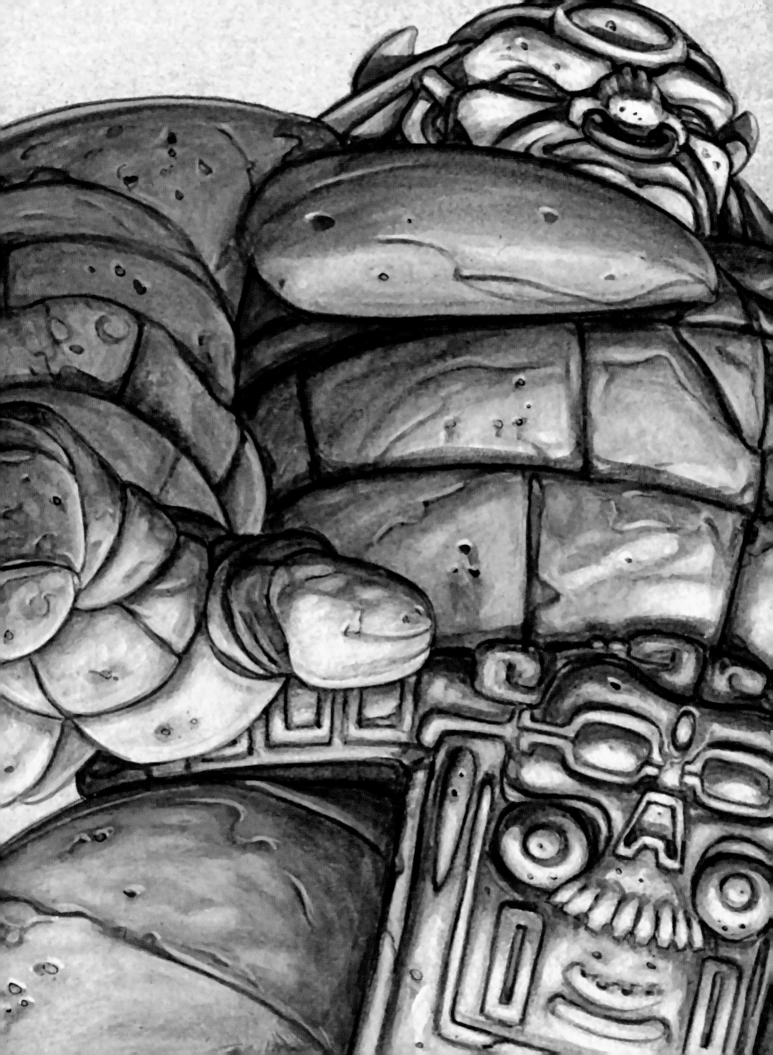

Hermia the winged avenger

Created by an eminent hierophant to cleanse the world of evil, Hermia was fashioned from blessed ivory and bone, and instilled with magic. Many men of ill-repute fell to her daggers. As she killed, she increasingly saw some taint of impurity in everything that met her gaze, and soon even her creator found himself subject to her judgment.

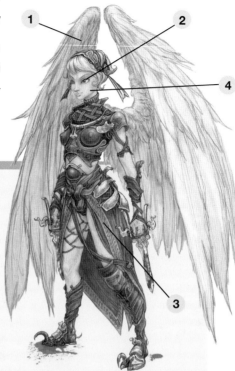

key characteristics

1. Wings are her most powerful limbs. Notice that the feathers are slightly coarse – she is pure, but a tireless warrior nonetheless.
2. Large eyes signify not innocence but omniscience. Nothing escapes her gaze.
3. Slight frame, and musculature not pronounced. She does not enter into combat – she executes judgment.
4. Porcelain skin emphasises her purity.

in the round

A slight frame suits an avian character, as does light armour consisting of leather, fabric and lacquer. For believability, ensure that the wings appear large enough to convincingly lift her in flight. Remember that the character is, in effect, four-armed, so the wings should probably join around the shoulders and not lower on the back. Notice how long the flight feathers are. When resting in a standing position, the wings should curve inward like arms.

facial expressions

Most of the time, Hermia wears an inscrutable smile – rather like the Mona Lisa – that resists interpretation. It reflects the fact that she keeps her own counsel and is beyond social interaction.

▶ **Looking up** *The feathers on her headdress serve both to highlight the direction of her gaze and to emphasise her airborne motion.*

Merciless judge *Hermia's sweeping gaze is never at rest as she tirelessly seeks out impurity wherever she goes.*

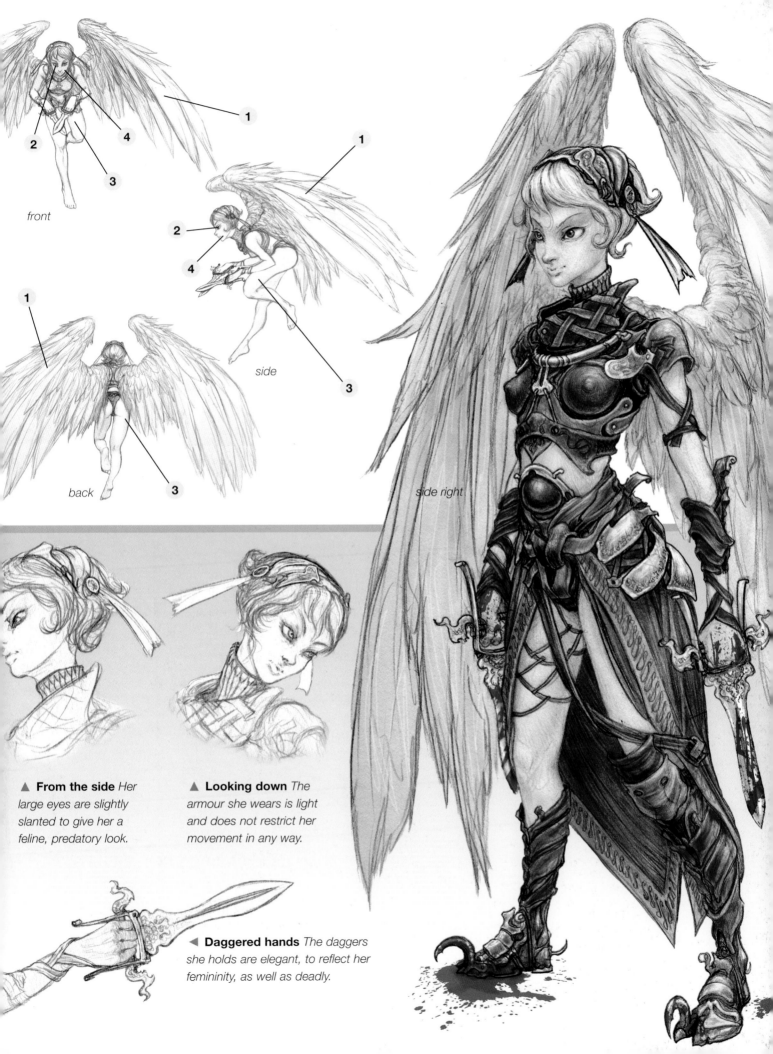

front

side

back

side right

▲ **From the side** *Her large eyes are slightly slanted to give her a feline, predatory look.*

▲ **Looking down** *The armour she wears is light and does not restrict her movement in any way.*

◄ **Daggered hands** *The daggers she holds are elegant, to reflect her femininity, as well as deadly.*

action poses

The action of flying introduces us to some interesting new styles and textures, as well as a whole new set of postures now that the legs are no longer load-bearing and take a bigger role in balance. This is where all those simplified skeletons you've drawn will really start to become useful as you draw your characters swooping and soaring through a range of aerial acrobatics with ease!

Soaring
Having launched into flight, Hermia is streamlined, holding her legs together and her arms close by her sides.

Striking
With her daggered hands, Hermia uses her speed and momentum to effortlessly deal death-blows to her victims.

Swooping
Coming in for the kill, Hermia's talons are raised to strike.

portfolio picture ▶
James Ryman
This beautiful yet terrifying creature shares Hermia's ivory skin and large, piercing eyes. Her flaming sword, her horns, her black armour and shield, and the horsetail flowing behind her are all redolent of the Apocalypse.

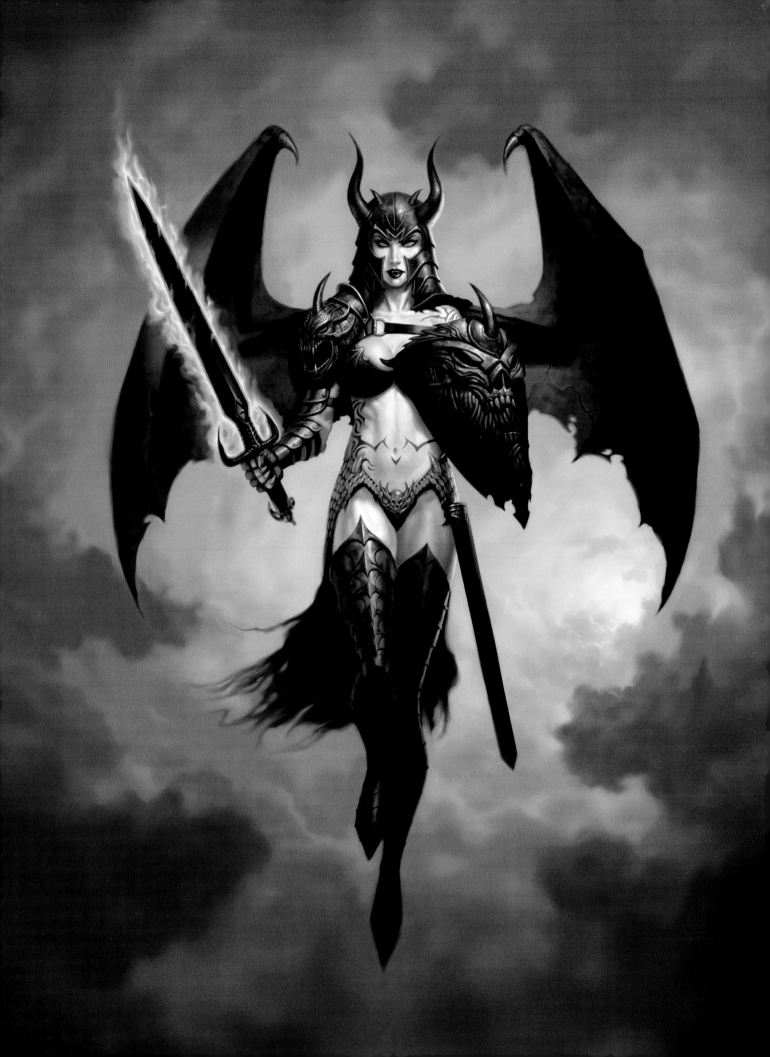

Sovann the werewolf

The werewolf has characteristics of both human and wolf – the difficulty is remembering which aspects belong where. Traditionally, the head, legs and tail are wolflike, but the torso and arm muscles are based on human anatomy, as are the leg muscles above the knee.

key characteristics

1. Head entirely that of a wolf.
2. Head mounted on front of shoulders.
3. Muscle groups in arms and torso very human.
4. Legs those of a wolf, although more upright and mounted more like human legs.
5. Hands human in structure but fingers tipped with large claws.
6. Toes protrude farther than on a wolf, and carry larger claws.

facial expressions

It is usually assumed that werewolves are quite primitive and don't have a wide emotional range. The mouth and nose don't have the same scope for movement as a human's, so the artist must rely on the eyes – and, of course, on body language.

▲ **From the side** *The open mouth and bared teeth – the werewolf's primary weapon – stress its character and impart a sense of menace. The ears, laid back, contribute to the overall expression.*

▲ **From the front** *This is the standard expression we might see in a sleepy domestic dog. You will need to use animal skulls as reference for structuring the face and positioning the features.*

from all angles

Posture and stance contribute to the development of characters. The neck is that of an animal, protruding in front of the shoulders rather than sitting above them, in a style which is suited to walking on all fours. The protruding head also creates a sharply hunched upper back, which can be exploited in side views. Another feature is that the heels never touch the ground, which makes the werewolf lean forwards imposingly, adding to the sense of menace.

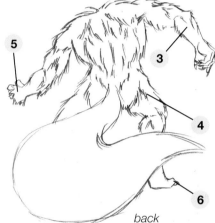

front side right

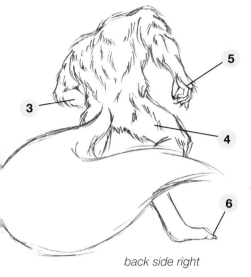

back side right

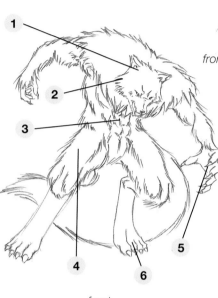

front

back

▶ **From the side** *The position of the head in relation to the body can add an extra degree of tension to an illustration. The creature could just be yawning, but somehow we doubt it!*

Magnificent beast *The artist has used a digital paint technique to soften the appearance of the fur to make it look thick and lustrous.*

▼ **Three-quarters** *The furrowed brow, closed mouth and pricked-up ears give a sterner expression.*

action poses

The hybrid of wolf and human traits extends into all the character's actions. He seems able to harness the most useful attributes of each form, which means you have to be able to draw both. A few simple variations on the standard can have dramatic results, making the creature either more human or more wolflike.

Running
When the werewolf runs, he leans so far forwards that he is almost on all fours. This posture is used to give the impression of speed, but it is also a canine characteristic.

Standing
In this illustration, he appears more human because he is standing tall on his hind legs.

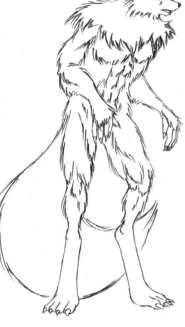

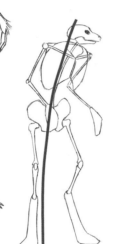

Roaring
Here his centre of gravity is much lower and he appears more like a quadruped.

Defending
His stance in this drawing combines elements of both man and beast to result in a pose that is not typical of either!

portfolio picture ▶
Martin McKenna
This werewolf is vastly more wolf than human. Because this creature transforms from one to the other, you can slide around on the scale making it more human or more wolflike as required. Even at this far-gone stage of transformation the legs retain their unusual shape.

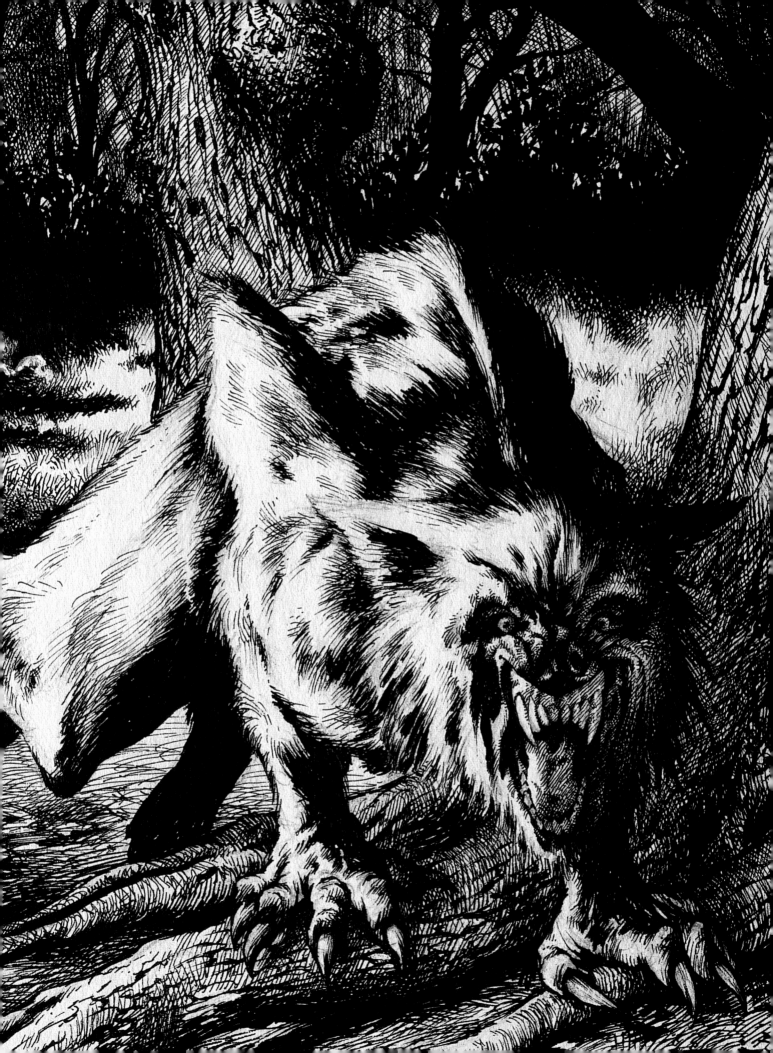

Mu the fat man

The Fat Man character borrows a lot from the Sumo wrestler. The muscles are barely defined beyond the suggestion of a bulge because they are covered by fat. Make sure the folds and sags of skin are in the right places, and incorporate secondary movement into the skin itself to give a better feeling of movement.

key characteristics

1. Minimal hair on face or head – the traditional look of the character. Here a ponytail is added to exploit secondary movement.
2. Muscles in the arms and legs are apparent, but are greatly softened by the layer of fat.
3. Morbidly obese, particularly around the torso, but strong enough to maintain good posture.
4. Minimal "Sumo-style" thong clothing.
5. Head small in relation to body, but also covered with fat.

facial expressions

This series of drawings illustrates the way in which increased fat can change the proportions of a face. This can present a few problems if you don't refer back to the basic skull structure.

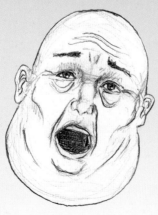

◀ **Looking up three quarters** *This example demonstrates the method of drawing the face on top of the skull's outline, adding the chin and cheeks afterwards.*

▲ **From the front** *Normally, the eyes would be in the middle of the head, but because the chin carries additional flesh, all features need to be situated higher than normal.*

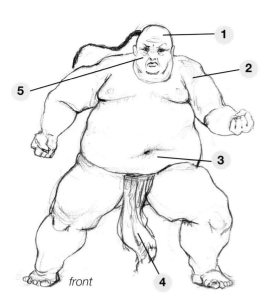

front

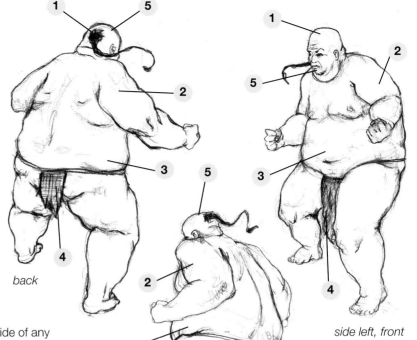

back

side left, front

side left, back

from all angles

Note the locations of the rolls of flab on the concave side of any joint, under the chin and at the back of the neck. When these are in place, it's simple to add extra weight as you build up from the skeleton – fat softens bone and muscle curves and has no set shape. But remember that the distribution of fat can constitute secondary movement and give the impression of action. Always remember to smooth the edges of any muscle group – use only high-definition lines for the edges of skin folds.

◀ **Three-quarters looking down** *When drawing a stern expression, it's best to slightly exaggerate it or it may come across merely as a feeling of discomfort!*

▶ **From the side** *Here again we see how the placement of the features departs from the norm. One trick is to treat the double chin as an appendix, rather like a beard, and use the skull as the reference for placing facial elements.*

Fat Man *Mu's extreme weight can be an advantage in a fight.*

action poses

The Fat Man's realism lies entirely in the way the flab is distributed. One helpful technique is to block out the larger groups of fat on the torso, upper arm and thigh during the skeleton stage. You can then easily draw around these, leaving you free to concentrate more on getting the skin folds looking right.

Swinging
Notice here how the belly is pushed out by centripetal force, adding to the realism. The ponytail and swinging weight contribute secondary movement.

Hopping
Varying the size of the skin folds can contribute to the impression of uneven fat distribution, especially when the body is seen from the back or front. Again, the position of the ponytail accentuates the impression of movement.

Sitting
The skin folds almost make the legs appear detached from the torso, heightening the foreshortening effect.

Reclining
With the body at rest, the fat is evenly distributed.

portfolio picture ▶
Michael Cunningham
The composition of this image accentuates this fat man's massive size – he is almost too large for the page, bursting out of its constraints.

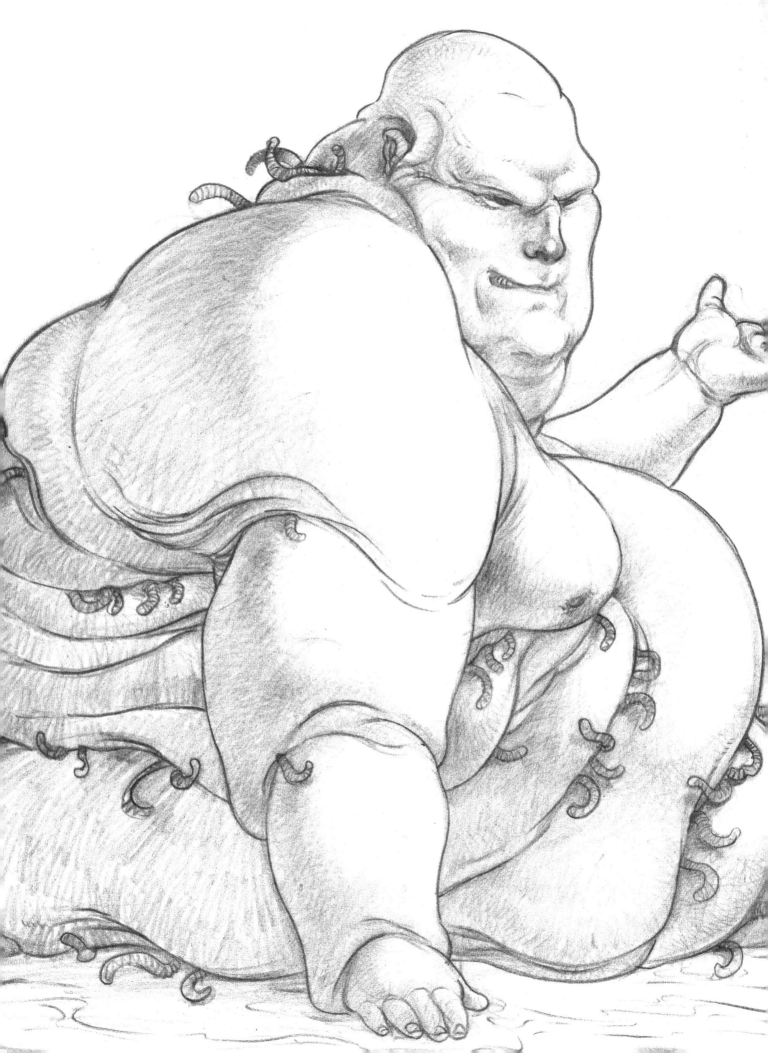

The barber's daughter

Possessed by the spirit of her father, who was put to death for spying, this young girl continues his work as an assassin, her form enabling her to avoid suspicion. The main anatomical differences to note for children are that the head is rounder and larger in comparison to the body, and the limbs are shorter and more curvy.

key characteristics

1. Notice how enlarged the eyes are – this is a common device used to make the character appear more innocent or inquisitive.
2. The features are drawn especially rounded, and the skin is unsullied by blemishes to promote a youthful look.
3. The oversized constrictive clothing highlights her meagre size.
4. Objects appear much larger and are handled differently in tiny hands. Her small fingers barely reach around the handle of the shaving razor.

front

from all angles

Compared to an adult character, the barber's daughter's head, hands and feet are much larger in proportion to the rest of her body. Also, the slightly enlarged eyes give an eerie and questionable sense of innocence.

side left

side right

back

Clothing

Although the barber's daughter's facial features are distinctive, and her skin is unusually pale, much of her character is communicated through her strange and unusual outfit.

distinctive features

Child characters, particularly girls, come with an enhanced air of innocence, so the inclusion of some suspect character traits and accessories, such as the shaving razor she carries, can provide this type of character with some eminently ominous and spooky undertones.

▶ From below
The oversized collar emphasises how small her face is.

▲ From above
The hair is soft, fair and wispy, like that of a baby. The simple braids are also typically childlike.

◀ From the side
The small, slightly upturned nose is another beguiling feature, usually considered cute and endearing.

▲ Hands *Again, her clothing accentuates her diminutive size. The bulky cuff of her coat-sleeve almost engulfs her hand.*

Possessed child
The barber's daughter is dressed in an outfit very complex and detailed for a child – younger characters usually wear more simple attire. But her bizarre appearance and her lack of expression, also unusual for a girl her age, add to this mysterious impression.

action poses

Children can be quite a task to draw, and their mannerisms and stance can be just as important as their anatomy. Of course, in this case, there's a purposeful juxtaposition of adult gesture performed by a child's body.

Running

Notice how the barber's daughter never appears to show any emotion, which creates an air of detachment around her character.

Jumping

Despite her cumbersome outfit, she is able to give dazzling displays of aerial agility.

Pushing

The structure of her body is similar to that of an adult, but the proportions are different. The sizes of the head, hands and feet are larger, as is the torso compared to the length of the limbs, although the pelvis is proportionally similar to that of adult females, who are generally drawn with hips wider than their shoulders.

Walking

Her physical attributes lie not in strength or speed but in stealth and lightfootedness.

portfolio picture ▶
Riana Møller
This young girl looks innocent, and yet her apparent calmness in such a bizarre setting, surrounded by alien creatures, suggests experience and an eerie confidence beyond her years.

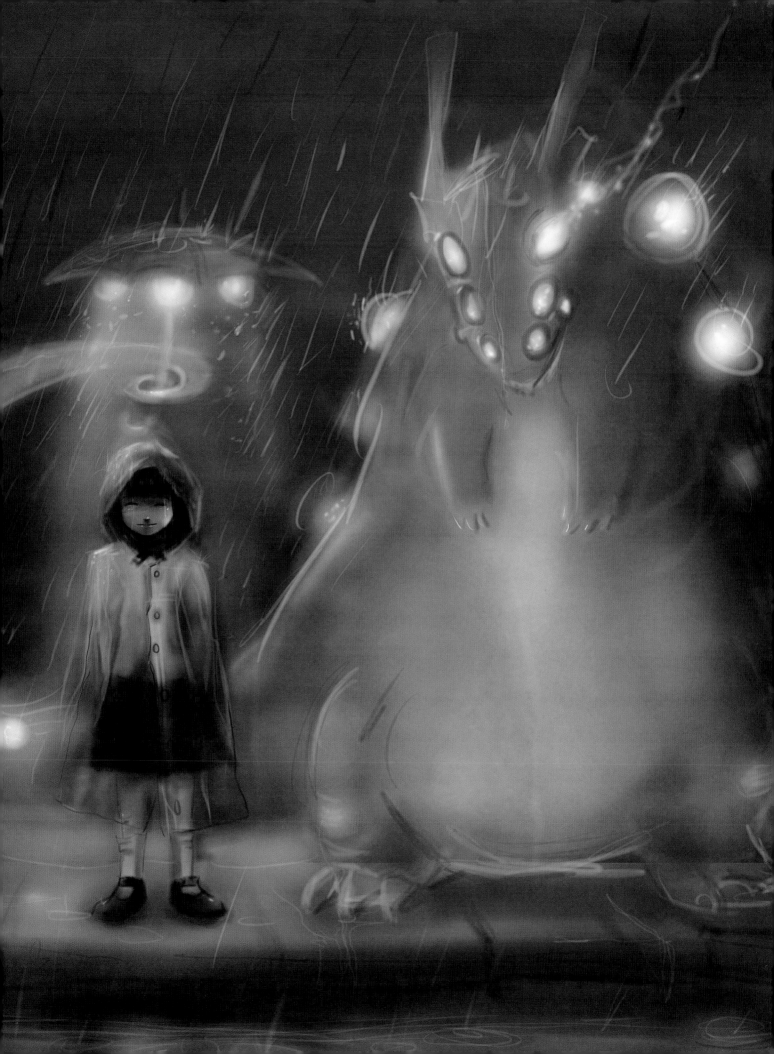

Grenvil the comic sidekick

A good friend to have in a fight, Grenvil is a hard-bitten, cantankerous old warrior and the hero's archetypal sidekick. He is quick to laughter, even quicker to his deadly axe, and loyal to the end. Strong and stocky, he sports a large belly and a thick, gnarly grey beard.

key characteristics

1. Unshaven and grimy, with impressive physique shaped by over-indulgence in drinking and eating, and late middle age.
2. Stout but extremely muscular physique – all muscle groups not hidden by flab are highly developed.
3. Huge belly.
4. Heavy "Viking-style" weapons and clothing.
5. Proportions uniformly broad and stocky.

facial expressions

Because Grenvil's face is mostly covered in hair, it can sometimes be difficult to convey a wide range of emotions. The trick for the artist is to use the possibilities inherent in this mess of hair to realise the full breadth of Grenvil's character and his expressive catalogue of laughter, howls, comic eyebrow raises, growls and humbugs.

▼ **Raucous laughter**

His eyes crease and his facial hair seems to take over in this unbridled gale of laughter. His sense of humour is broad and jolly and anyone can expect to become a target of his cruel fun.

▲ **From the side**

A furrowed brow expresses a sense of comic disbelief.

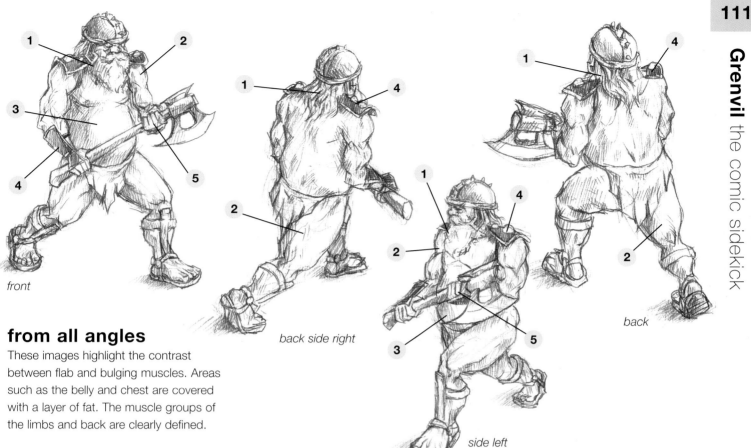

front

back side right

side left

back

from all angles

These images highlight the contrast between flab and bulging muscles. Areas such as the belly and chest are covered with a layer of fat. The muscle groups of the limbs and back are clearly defined.

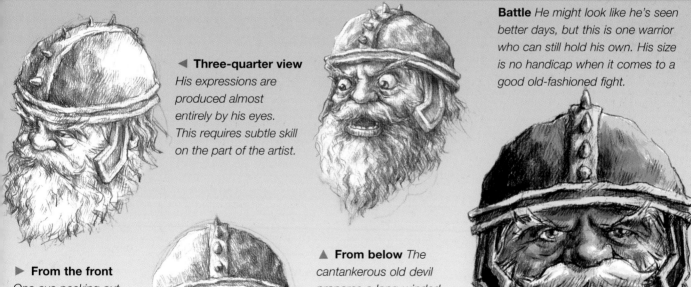

◀ **Three-quarter view**
His expressions are produced almost entirely by his eyes. This requires subtle skill on the part of the artist.

Battle *He might look like he's seen better days, but this is one warrior who can still hold his own. His size is no handicap when it comes to a good old-fashioned fight.*

▶ **From the front**
One eye peeking out from beneath a mass of eyebrow and tangled hair speaks volumes about Grenvil's character.

▲ **From below** *The cantankerous old devil prepares a long-winded lecture. He uses his eyes for comic emphasis.*

action poses

It's easier to get away with a bit of artistic licence when drawing Grenvil in an action pose because his stocky and stout physique means movement is seldom graceful and can often be buffoonish. However, there are a few important rules that you need to remember.

Pulling

An indication of difficulty with a physical task can add an extra touch of realism. In this illustration, the body is positioned somewhat awkwardly and the heel of the right foot is raised.

Ready to fight

The portly Grenvil has a fairly restricted range of movements, so the stances should not be too exaggerated. This is about as extreme as it gets!

Stepping

Any secondary movement of the hair and clothing should be kept to a minimum in order to make the body movement appear slow. For the comic sidekick, brute power always comes before stealth.

Ramming

As this illustration clearly shows, the body leans at only a slight angle, suggesting slothfulness, but the bulging leg and upper body muscles belie this to give the impression of real strength.

portfolio picture ▶
Greg Staples
This interpretation of the archetypal comic sidekick focuses on the character's bravery and fighting prowess over his clownishness and slightly comical physical appearance.

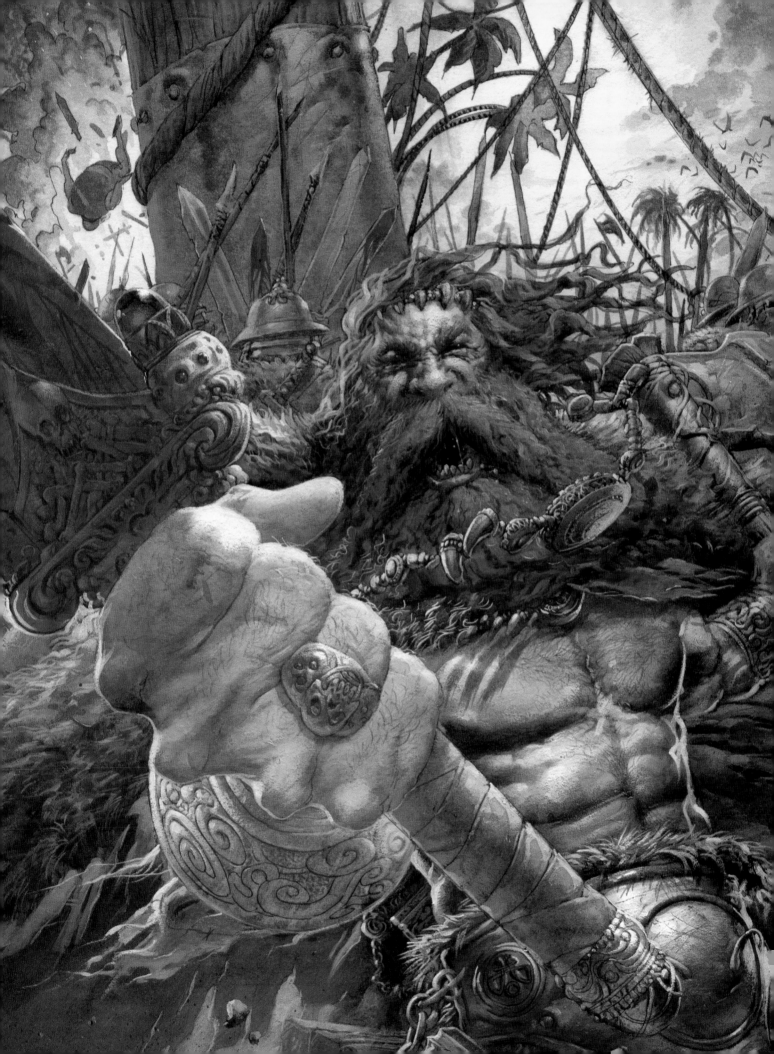

Orin the ogre

Orin is built with potential as a comic character, and as such he needs to be able to appear in positions that appear humorous. This may be dictated by the pose itself, but more importantly by the structure of his skeleton (squat and stumpy), the distribution of his muscles (hunched and awkward) and his covering of fat (primarily in his large potbelly).

key characteristics

1. Enlarged mouth, nose and ears.
2. Prominent veins on arms and legs – generally considered too unattractive for fantasy heroes and heroines.
3. Missing teeth contribute to the grubby and unsanitary overall impression.
4. Uneven distribution of muscles.
5. Huge hands and feet.
6. Vast, overflowing abdomen.

side left

back

front

from all angles

Here we can see how weight distribution can have a huge effect on stance and movement. Orin's large gut in particular greatly affects his movement, making him hunch forwards to compensate for being top-heavy when he moves.

side right

facial expressions

An interesting feature of Orin's face is that it is similar enough to that of a human to make some very familiar expressions, but also different enough to do some distinctly scary things. It all depends which elements you choose to focus on.

Weapons *These are used mostly as an extension of a character—which is why Orin's club is big, heavy and clumsy.*

▶ **Three-quarters**
The eyes, often the most expressive facial feature, convey a familiar shifty look that seems quite human.

◀ **From the side and to the back** *One of Orin's inhuman features, the oversized nose, is given a sharp focus by squashing up the features around it – furrowing the brow and half-closing the mouth.*

▼ **From the side and to the back** *Here we centre on Orin's colossal, revolting mouth. It opens wide enough to distort his whole head beyond any human capabilities – scary!*

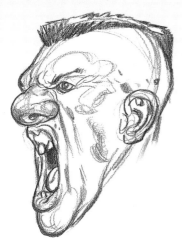

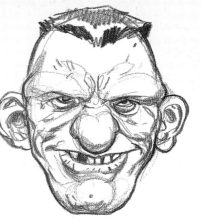

▶ **From the front**
And now we see half and half – a human expression given a humorous quality by the unusual proportions of the features.

action poses

Orin's posture and movement are principally dictated by the weight of his torso. The artist has chosen to depict this initially as the skeletal model, as this makes it easier to see early on how comfortable the figure looks in any position. Remember, there are no strict rules for blocking out – just find a way that works for you.

Leaning
The dramatic foreshortening on the arms and legs gives the impression that Orin is leaning heavily towards the viewer.

Crouching
Here Orin holds his heavy torso close to the ground, giving a real impression of his unwieldy weight.

Graceful *A hint of Orin's playful side!*

Kneeling
Orin holds himself much like a sumo wrestler and moves clumsily.

Ready for action
This is an excellent fantasy pose – exaggerated beyond belief, dynamic, with loads of impact and with a brilliantly weird expression!

picture portfolio ▶
Glenn Fabry
The pronounced Neanderthal forehead and the huge, outsized jaw and nose dwarf the eyes and lips, making them oddly delicate and unnattractive.

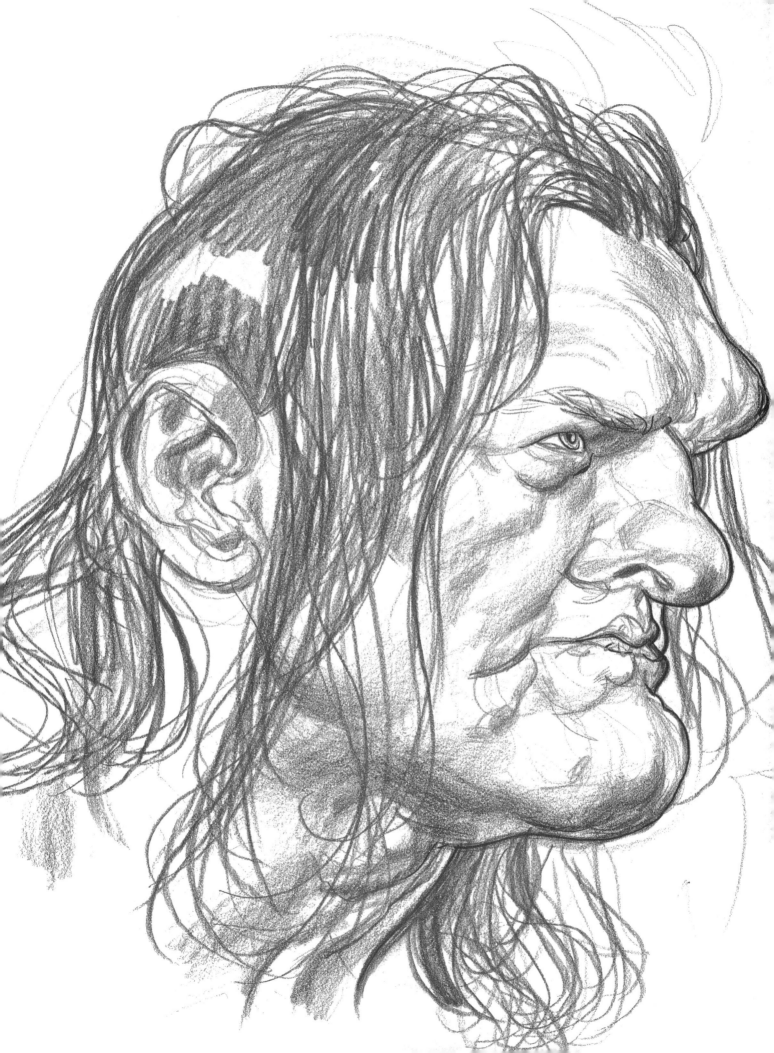

Gobbo the goblin

As fantasy archetypes go, Gobbo is very much the runt of the litter. Whereas some characters are corrupted by power or strength, Gobbo's unpleasantness is mainly caused by his resentment at being one of the most downtrodden, exploited and kicked-about figures in fantasy literature. As such there's no depth of depravity that he won't sink to in order to satisfy his evil cravings for revenge.

facial expressions

Gobbo is arguably the most expressive fantasy archetype, which is why his features are so human. When constructing a facial expression, it can be useful to think of him as a destructive, hyperactive child – emotionally highly charged, attention-seeking and permanently frustrated.

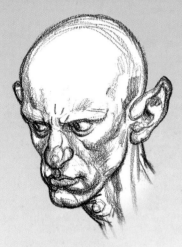

► From the side
Caught off-guard, we see how melancholy Gobbo can be without a distraction.

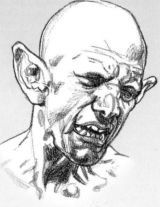

▲ **Three-quarters**
Thoughtful and observant – this is an excellent example of how similar Gobbo's face is to that of a human.

◄ **Three-quarters looking down** *Manic depressive right now, but don't worry, in a few moments he'll have forgotten all about it.*

► From the left and to the back *Disgust? Thoughtfulness? Just a "faraway look"? Who's to say? It's a good idea occasionally to let a character run loose and let him do what you feel without having to justify his every expression.*

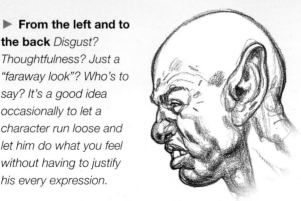

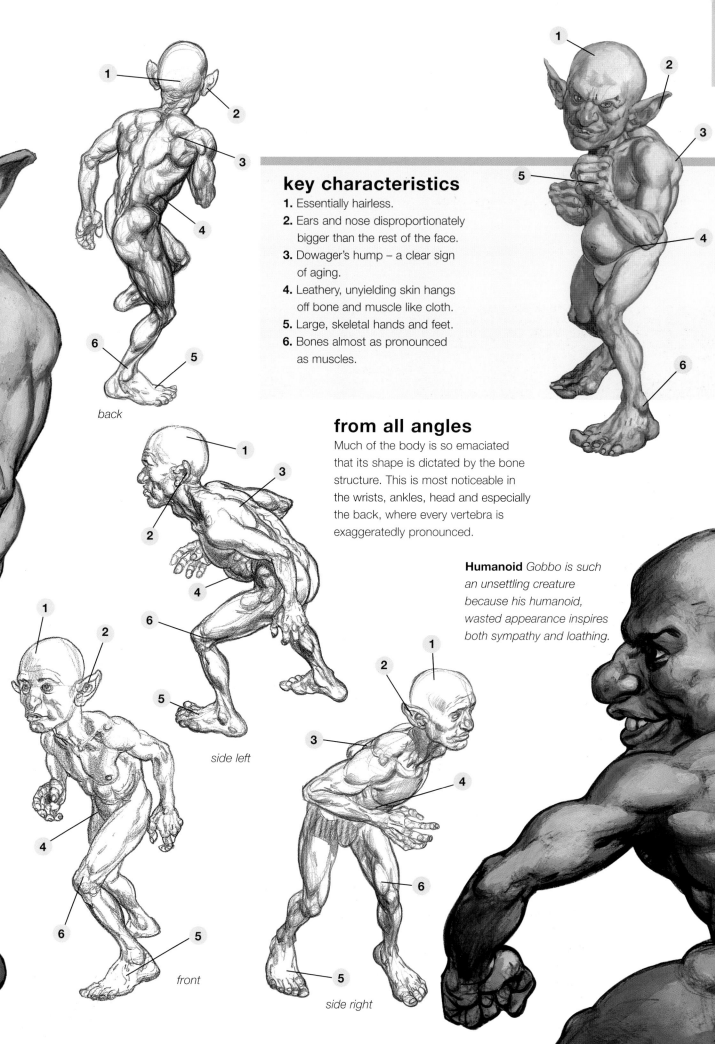

back

key characteristics

1. Essentially hairless.

2. Ears and nose disproportionately bigger than the rest of the face.

3. Dowager's hump – a clear sign of aging.

4. Leathery, unyielding skin hangs off bone and muscle like cloth.

5. Large, skeletal hands and feet.

6. Bones almost as pronounced as muscles.

from all angles

Much of the body is so emaciated that its shape is dictated by the bone structure. This is most noticeable in the wrists, ankles, head and especially the back, where every vertebra is exaggeratedly pronounced.

Humanoid *Gobbo is such an unsettling creature because his humanoid, wasted appearance inspires both sympathy and loathing.*

side left

front

side right

action poses

Gobbo's look is that of a humanoid creature who has thwarted death and remained agile for many hundreds of years, but has been ravaged beyond recognition by age. Indeed, in many fantasy stories this is how goblins come about.

Posing

Again, we see how Gobbo will humour himself by striking a pose, even when in a relaxed state. Note that although the skin sags on the front of the torso, the rest of the body is well-defined by bone and muscle.

Bending

When relaxed, Gobbo likes to position himself like a predator – close to the ground and ready to leap into action. We also see how even his thigh undulates with lumpy muscles.

Crouching

Here we see how Gobbo positions himself when he really is in trouble – his expression says "I'm nervous", and his posture says "I'm vulnerable".

Running

This stance is unusually upright for Gobbo, but it illustrates very well the similarities in skeletal structure between a goblin and a human child – or a human 204 years old!

portfolio picture ▶

Michael Cunningham

The goblins in this work by Michael Cunningham are slightly taller and more upright than Gobbo, but they retain his trademark unpleasant looks and evil behaviour.

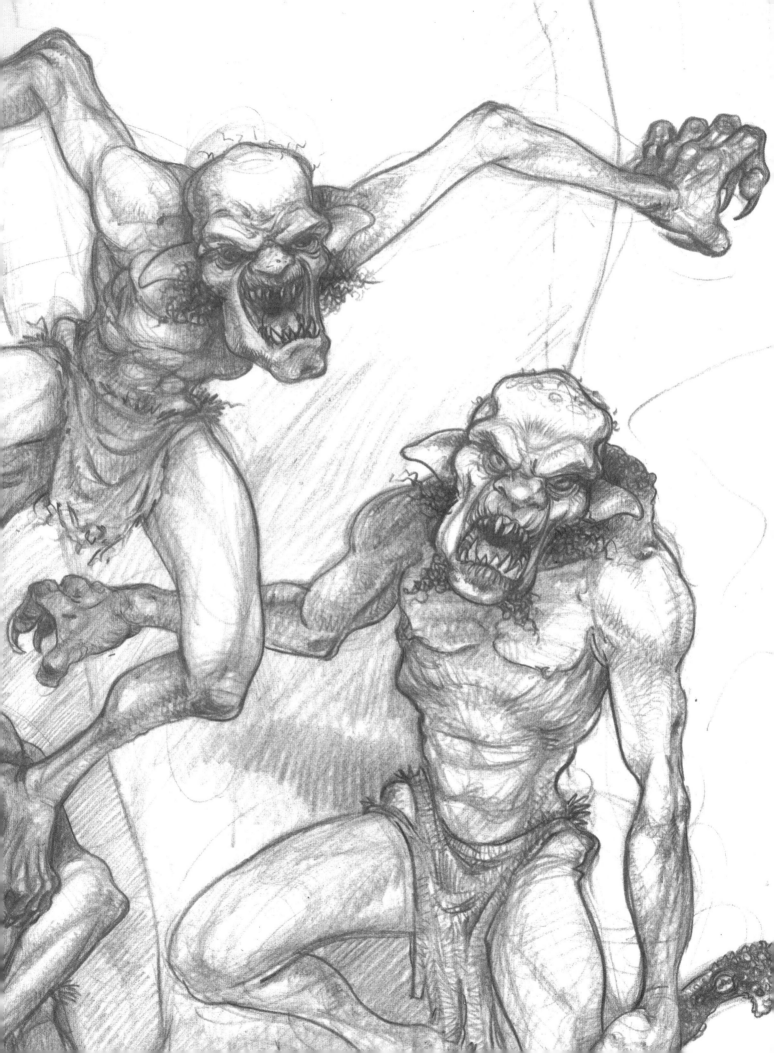

Kyvar the lizard

Every character needs a hook – a distinctive feature that sets it out from the rest. Kyvar, as a gigantic lizard, fits the bill perfectly. As important as it is for a character to be different, it's also vital that all fantasy characters share a few simple universal traits. Kyvar also illustrates these similarities.

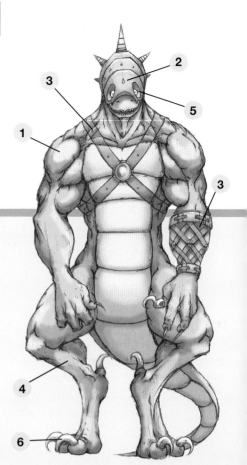

key characteristics

1. Exaggerated shoulders and arms – important for any hero whose strength doesn't lie in the supernatural.
2. Distinctive facial expression.
3. Minimal, carefully chosen accessories.
4. Upright legs make him appear bipedal, but with lizardlike joints.
5. Eyes mounted at the front – a trait associated with predators, and a must for all fantasy combat characters.
6. Huge claws – remember the golden rule: if it looks good, exaggerate it!

hand gestures

The structure of Kyvar's hands borrows heavily from that of a human's, a common trait in nonhuman fantasy figures. There is a slightly sharper bone structure and bulkier muscles as well as the obvious differences in the number of digits and the large claws that adorn them.

► **From the front** *Note how bulky the digits are compared to the palm.*

◄ **From the side and to the back** *The bone structures of the wrist and digits are very similar to that of a human – use your own hand as a reference.*

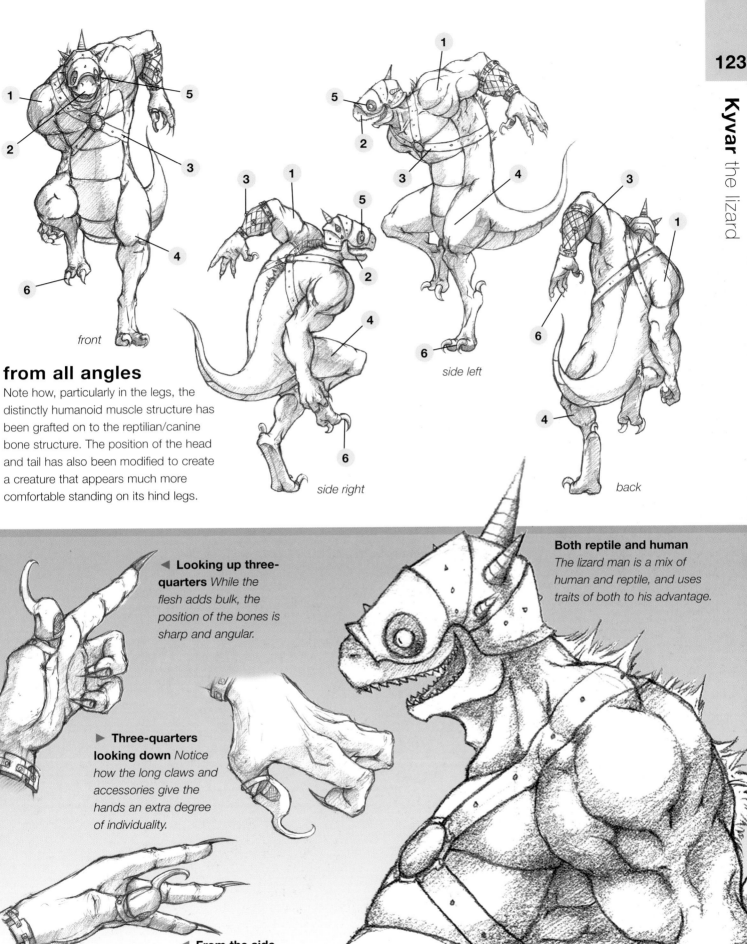

front

from all angles

Note how, particularly in the legs, the distinctly humanoid muscle structure has been grafted on to the reptilian/canine bone structure. The position of the head and tail has also been modified to create a creature that appears much more comfortable standing on its hind legs.

side right

side left

back

◄ **Looking up three-quarters** *While the flesh adds bulk, the position of the bones is sharp and angular.*

► **Three-quarters looking down** *Notice how the long claws and accessories give the hands an extra degree of individuality.*

◄ **From the side** *The digits at full extension are straight and strong.*

Both reptile and human
The lizard man is a mix of human and reptile, and uses traits of both to his advantage.

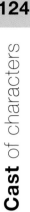

action poses

Part of creating a realistic illustration is adapting bone and muscle structure so the figure looks comfortable in any position. Kyvar's body must be able to switch between biped and quadruped, which is achieved by modifying the structure of his reptilian legs and positioning his head so it faces forwards and upwards.

Crawling
Here we see that Kyvar is as comfortable on four legs as he is on two.

Attacking
Smooth reptilian skin makes shading a lot easier, so remember to accentuate those bulging muscles with bold outlines.

Hopping
Big muscles are a must, but remember that there's a compromise between ease of movement and muscle size.

Charging
Notice how Kyvar's whole body is at an incline – you can make a character appear more dynamic by increasing this angle of movement.

portfolio picture ▶
Michael Cunningham
The addition of chain mail, primitive weapon and aggressive posture result in a very different reptilelike creation than on the previous pages.

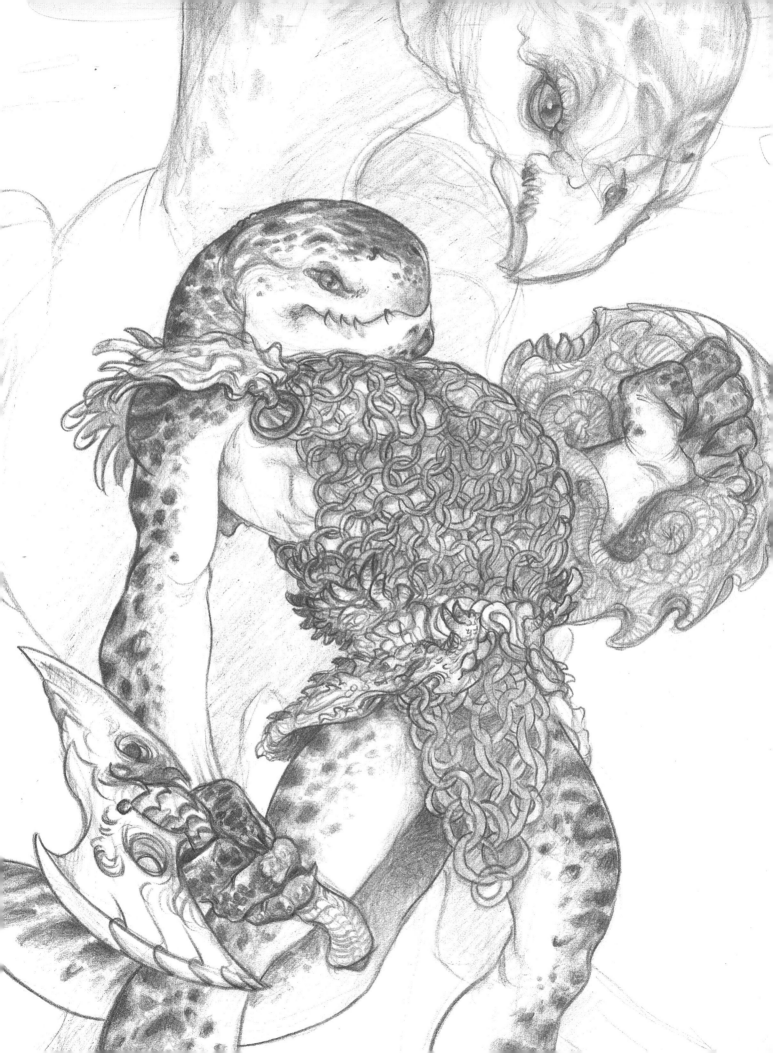

Index

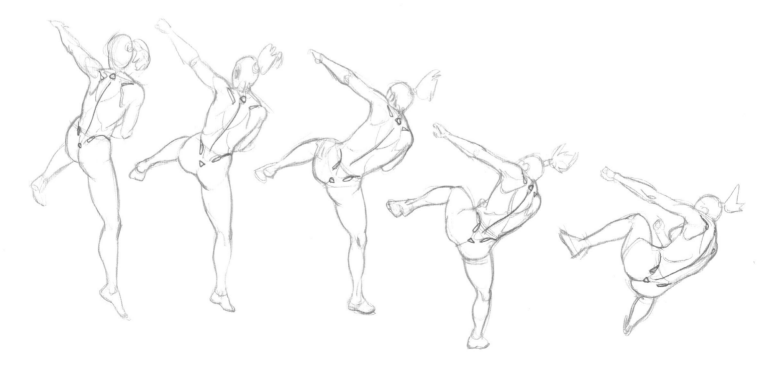

Credits

Quarto would like to thank and acknowledge the following artists for supplying illustrations reproduced in this book:

1 Michael Cunningham
2 Maurizio Manzieri
8l © Rebellion A/S. All Rights Reserved. www.2000adonline.com
15 Liam Sharp
17l Joe Calkins
20 Matt Haley
21l Michael Cunningham
21r Matt Haley
22–23 Matt Haley
24b Al Davidson
25br Al Davidson
28l Jose Pardo
28r Michael Cunningham
29t Michael Cunningham
29b Ron Tiner
30l Jan Patrik Krasny
30tr Joe Calkins
30br © Rebellion A/S. All Rights Reserved. www.2000adonline.com

31 Keith Thompson
32–33, 48t, 48c, 48br, 49bl Michael Cunningham
49t, 49br Ron Tiner
50, 51b Michael Cunningham
51t Liam Sharp
52–53 ILYA
74–75, 76 Liam Sharp
78–79, 80 Michael Cunningham
82–83, 84 Keith Thompson
86–87, 88 Aya Suzuki
90–91, 92 Liam Sharp
94–95, 96 Keith Thompson
98–99, 100 James Marijeanne
102l, 102tr, 103br Rob Sheffield
102bc, 102br, 103t, 103bl, 103bc, 104 Jonathan Opgenhaffen
106–107, 108 Keith Thompson
110–111, 112 Chris le Roux
113 Greg Staples © 2005 Wizards of the Coast, Inc
122–123, 124 Michael To

This comprehensive list also includes the artists who are acknowledged beside their work:

Joe Calkins www.cerberusart.com; Michael Cunningham maedusa109@hotmail.com; Al Davison; Matt Haley www.matthaley.com; Matt Hughes www.matthughesart.com; ILYA edilya@hotmail.com; Jan Patrik Krasny http://patrik.scifi.cz; Corlen Kruger corlenk@mweb.co.za; Maurizio Manzieri www.manzieri.com; James Marijeanne www.marijeanne.pwp.blueyonder.co.uk; Martin McKenna www.martinmckenna.net; Riana Møller www.fealasy.deviantart.com; Jonathan Opgenhaffen jopenhaffen@lycos.com; Jose Pardo josepar@bellsouth.net; Chris le Roux chris.leroux@ntlworld.com; James Ryman www.jamesryman.com; Liam Sharp www.bigwowart.com/users/liamsharp/; Rob Sheffield; Greg Staples greg@arkvfx.net; Aya Suzuki aya@suzukis.nildram.co.uk; Keith Thompson www.keiththompsonart.com; Ron Tiner; Michael To m.to@rave.ac.uk

All other illustrations and photographs are the copyright of Quarto Publishing plc. While every effort has been made to credit contributors, Quarto would like to apologise should there have been any omissions or errors—and would be pleased to make the appropriate correction for future editions of the book.

Additional text by Kevin Crossley

AUTHOR'S DEDICATION
Lots of love to Nikki, Tom and Kitty